GET NOTICED!

NORTH LIGHT BOOKS
CINCINNATI, OHIO
www.howdesign.com

Sheree Clark and Kristin Lennert

Get Noticed! Self-Promotion for Creative Professionals. Copyright © 2000 by Sheree Clark and Kristin Lennert. Manufactured in China. All rights reserved. No part of this book may be reproduced in any form or by any electronic or mechanical means including information storage and retrieval systems without permission in writing from the publisher, except by a reviewer, who may quote brief passages in a review. Published by North Light Books, an imprint of F&W Publications, Inc., 1507 Dana Avenue, Cincinnati, Ohio 45207. (800) 289-0963. First edition.

Other fine North Light Books are available from your local bookstore, art supply store or direct from the publisher. Visit our Web site at www.howdesign.com for more resources for graphic designers.

04 03 02 01 00 5 4 3 2 1

Library of Congress Cataloging-in-Publication Data
Clark, Sheree L.
 Get noticed! self-promotion for creative professionals / Sheree Clark and Kristin Lennert.
 p. cm.
 Includes index.
 ISBN 0-89134-985-5
 1. Arts—Marketing. 2. Arts—Vocational guidance. I. Lennert, Kristin. II. Title.
NK634.C58 2000
741.6' 068 ' 8—dc21 99-42463
 CIP

Edited by Lynn Haller and Donna Poehner
Production coordinated by Kristen Heller
Interior designed by Sayles Graphic Design
Cover illustration and design by John Sayles

The permissions on pages 136–43 constitute an extension of this copyright page.

ABOUT THE AUTHORS

GET NOTICED! is co-authored by Sheree Clark and Kristin Lennert, who met for the first time in 1988.

Sheree Clark is a native of Saratoga Springs, New York. Since 1985, she has been a principal of Sayles Graphic Design in Des Moines, Iowa, cultivating relationships with clients around the world but making time to pursue her love of writing. She has authored numerous articles for graphic arts trade publications as well as two graphic design books: *Creative Direct Mail Design* and *Great Design Using Non-Traditional Materials*. Clark holds a bachelor of science degree in Retail Marketing from Rochester Institute of Technology and a master's degree from the University of Vermont. Clark's passion for design extends to her free-time activities: She collects art deco compacts and jewelry, Lucite handbags, and industrial design and packaging from the 1930s.

Kristin Lennert began writing at the age of seven and hasn't stopped since. Her short stories and poetry have been published in journals, annuals and educational periodicals. A one-time aspiring journalist, she received a bachelor's degree from Drake University and turned her writing skills into a career in advertising. She is an experienced media buyer, broadcast writer and promoter. Her interest in graphic design began in earnest in 1995 when she joined the staff of Sayles Graphic Design. Lennert is a dedicated musician and is most proud of the 1932 Wurlitzer upright piano that resides in her music room.

Acknowledgments

Heartfelt thanks are due to many people for their part in making this book a reality, including each creative professional who submitted his or her work. We would also like to acknowledge a number of special people for their specific contributions.

Carey Rezac, our dedicated editorial assistant, for her creative and enthusiastic work.

Lynn Haller and Donna Poehner, our editors, for their ongoing support throughout the writing, editing and publishing process.

Bill Nellans for his outstanding photography of the feature case study projects.

John Sayles for his cover design and book layout, and Som Inthalangsy for his fine production work.

And finally, our families, friends, co-workers and significant others who cheerfully put up with lost nights and weekends, and who listened to our tales of woe and excitement.

TABLE OF CONTENTS

GET NOTICED!

SECTION THREE:
Gallery **72**

FOREWORD

John Sayles, Principal, Sayles Graphic Design

We creative types—designers, illustrators, photographers and the like—spend a lot of time thinking about and talking about self-promotion. We spend very little time actually doing it. There are probably lots of reasons for our inability to focus on the business of self-promotion. For some of us, it's the fact that we're creatives, not "suits," and many of us take a kind of pride in being nonbusiness types. And let's not forget our schedules: We're burning the midnight oil for our clients, and we certainly can't put self-promo ahead of that!

But there are even more, and far better, reasons why we must attend seriously to self-promotion. For me, there's one compelling reason to promote myself and my firm: so that I can get exactly the kind of work I want. Of course, you may already be getting the kind of work you want to do. But beware: No client relationship lasts forever; if you're not expanding your base of new business contacts, you're losing ground every day to your competition.

When I started my studio in 1985 with my partner Sheree Clark, the business climate was significantly different from what it is today. Our firm was a business with a decidedly local orientation. Our clients, suppliers and focus were all local. Gradually, we decided that if our business was to grow, we had to turn our attention outward. We wanted to have a wider presence geographically, and we sought to attract larger and more prestigious clients. At about the time we were making these determina-

tions, the world was starting to shrink. Overnight delivery services, fax machines and eventually E-mail would all impact how we did business and the success with which we could position ourselves as a studio with a nationwide presence.

Today our firm has clients all over the United States and in several parts of the world. This didn't happen by luck or chance. It came about because we have a plan we doggedly implement day after day, year after year. The plan changes as our needs, and the times, change. Our plan includes media relations, direct mail, events, participation in design competitions and many of the other things covered in this book. After fifteen years of acquiring successively better projects, more awards and increased media coverage, I can tell you that having, and implementing, a plan is a key to success.

If you are a creative professional just striking out on your own, in a way I envy you. Strange as it may seem, when you are just beginning your business and no one has ever heard of you, you have an advantage. You can build your image in precisely the way you want it to be built. And more often than not a creative person's first self-promotion efforts will be produced on a shoestring budget. This might seem like a challenge, but in many cases it can turn out to be a benefit, because what people respond to are good ideas. Ideas that aren't overshadowed by four-color printing and expensive paper. Ideas that allow you to use your talents, to push yourself to new levels and to make a name for yourself. And in the end, isn't that the real reason for self-promotion?

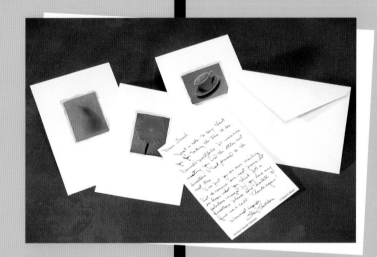

The best answer to the question, "Why should I promote myself?" is one word: exposure. The more people who know what you do—or what you want to do—the better your chances at getting what you want.

WHAT IS SELF-PROMOTION?

Self-promotion is anything you do that:

- Establishes your image
- Develops new opportunities for you
- Makes contact with prospective clients

TAKING THE FIRST STEP

The first step in establishing your self-promotion is simple, but it requires discipline: Treat your self-promotion project as you would treat a regular, paying client job. Give it a job number, set up a file and assign someone to be in charge of the project. Start now to make a timeline. Develop a schedule for your promotion project, and stick to that schedule.

DEVELOPING SELF-PROMOTION GOALS

The adage "If you don't know where you're going, how will you know when you arrive?" applies to self-promotion! Before you design a mailer, write a news release or accept a speaking engagement, ask yourself what you expect your self-promotional efforts to accomplish. Options might include the following:

- Develop or enhance an image
- Change an existing or perceived image
- Increase or expand your client base
- Relocate or establish a presence in another market
- Get more work
- Get more (or different) kinds of work
- Get better-paying work

WHO IS YOUR AUDIENCE?

Next, ask yourself who your audience is. Look at the list of goals you've established and think of where you'll need to have exposure in order to accomplish

n a broad scale first,
not be too cavalier ("all
xample, is too sweep-
our broad audience

ational media

encies
ss categories (for exam-
oftware companies,
es, etc.)
or universities

hin the organizations
most needs to hear
les can include:

keting
ertising

or
munications Director

loyee Communications

of all the ways in
enerate attention for
firm. The following

suggestions will get you started.

- Have your work published in awards
 annuals and books
- Receive media coverage locally (make
 a list of possible publications)
- Receive media coverage nationally
 (make a list of possible publications)
- Send self-promotional mailings to
 prospective clients
- Give talks and presentations to groups
- Be quoted in articles about design
 issues

Congratulations! You have just begun the
process of defining your self-promotion
goals. Armed with this information and
a commitment to persevere, you are
ready to learn more about the nuts and
bolts and get noticed!

THE NUTS AND BOLTS OF SELF-PROMOTION

10

GETTING YOUR WORK PUBLISHED

By having your work published in awards annuals and trade reference books, you establish credibility for your firm at the same time you're promoting yourself. By developing an organized and strategic approach to submitting your work for consideration, you increase your chances for success.

AWARDS ANNUALS AND COMPETITIONS

There are all sorts of juried and non-juried competitions for design, illustration and photography professionals on the international, national, regional and local levels. Some are for special interests (annual reports, editorial design, university publications, etc.) while others are for specific disciplines (book design, typography, environmental design, etc.). Many competitions are sponsored by magazines and publishers, others by trade associations, and still others are supported by private companies and organizations. There are competitions that are relatively easy to get work into, and there are others with very stringent guidelines and, thus, tougher odds.

Most competitions occur on a regular basis, usually annually. The most well-regarded competitions publish some sort of an annual or awards book to document winning entries, which makes them valuable as self-promotion vehicles. Clients, prospects and others view these annuals as documented proof that your firm—and you—possess expertise in your field and are recognized by your peers.

DECIDING WHICH COMPETITIONS TO ENTER

The most efficient and productive method for entering competitions of any kind is to first become familiar with the competition and, if applicable, the organization sponsoring it. While there will be many opportunities for you to put your work forth for evaluation, it is up to you to decide which competitions are worthy of your attention and, in many cases, your entry fee. Among the criteria you might want to establish for evaluating competitions are:

• The credibility of the competition and the sponsoring group itself. Have you ever heard of it? Is it held in high regard by your colleagues and/or your clients?
• The means by which the winners of a particular competition are announced. A competition that publishes or circulates its results to a wide audience will be more attractive to you than one that does not. Likewise, the makeup of that audience will be important to you.
• The judging procedure itself. Does the system sound fair? If a panel of judges is announced in advance of the deadline for entries, do you respect the individuals on that panel?
• The cost involved in entering. If there is an entry fee, will winning an award justify what you had to spend to be considered?

11

FINDING OUT ABOUT VARIOUS OPPORTUNITIES

The chances are good that if you belong to professional organizations, subscribe to trade publications and are generally active in your discipline, you are aware of many competitions to submit your work for evaluation. Still, you may be missing opportunities to have your work represented. *HOW* magazine, a bimonthly publication for graphic designers, publishes a schedule of annual competitions for designers and those in allied fields in their December issue, and will give you an idea of the variety of opportunities available to you.

In addition to the national competitions, there are many others at the local and regional level. Although most of these do not result in a widely circulated annual or special edition of a magazine, they may be of value to you in your local market. Contact local professional organizations in your area to find information on their awards programs.

PREPARING YOUR ENTRIES

Before you develop your list of potential submissions to a particular competition, you'll want to first study the criteria the competition has established for entries. Usually presented in a "call for entries" document, the criteria spells out such important details as competition dead- line, eligibility requirements and categories for submission, as well as particulars about where the entries should be sent and even how to package or present them. Some of the more highly regarded competitions receive literally thousands of entries, making it all the more important that your submissions comply with the established guidelines. Your odds of receiving recognition are increased if you adhere to the instructions of the competitions' organizers. You may even be disqualified if you don't follow their guidelines to the letter.

You'll probably want to establish a budget for entering competitions, perhaps based upon the average number of pieces you enter on a yearly basis. Don't forget to factor in acceptance or hanging fees, as well as the "hidden" costs of entering, such as overnight couriers or the cost of making prints.

Some firms have developed sophisticated procedures for compiling competition entries. This might include the maintenance of a detailed list of all work eligible for competitions, or the identification of a specific person who is responsible for all of the firm's submissions throughout the year. Other firms have developed checklists and other administrative methods to make the process more efficient. The following Competition Entry Checklist may be helpful to you as you devise your own process for organization of your competition entries.

TIPS FROM COMPETITION ORGANIZERS

• Do submit an actual printed sample of your work, rather than a photograph or slide, unless the competition rules specify otherwise. Judges generally prefer to see the real thing when they're evaluating entries.

• Make sure that your entry is well protected. Always ship in sturdy boxes. Never send glass-mounted slides, and take care when packaging posters.

• Make sure your entries are in good shape to begin with. If your entry is yellowed with age or dog-eared, it won't look good in the annual even if it is accepted—which isn't likely.

• Make absolutely sure you read all the contest rules and see that your piece really qualifies for the competition and category you're entering.

• Print legibly—or better yet type—your entry forms. Competition organizers don't have time to call you to clarify information.

• Specify the correct category for your entry. Read and reread the call for entries to be sure you have it in the right spot.

• Make sure you include information on the software used—plus how to open the file—if you're entering a project in a digital or electronic medium.

• Keep the various pieces of a campaign together when you ship them.

• When you ship multiple packages, mark the outside or each "1 of 2," or "2 of 2," etc.

• Be sure you've included the entry fee with your entry!

COMPETITION ENTRY CHECKLIST

Competition:

Sponsor:

Deadline:

○ Read the entire call for entries completely and carefully; highlight any areas needing special attention.

○ Review summary of our most recent entries to that competition. Also review past printed annuals.

○ Start a summary sheet for the current competition. Include the correct name of the competition, deadline, eligibility, fees, notification, and an area to list entries.

○ After entries have been decided, record them on the summary sheet using complete titles and descriptions including the year produced. Also indicate exactly what was sent (components of a campaign, for example) and in what form (sample, slide, photo, etc.).

○ Type individual entry information on entry forms. Verify spelling of all names and correct titles.

○ Proofread entry forms against summary sheet.

○ Reread the call for entries.

○ Place the entry forms on entries as indicated in call for entries. Be sure forms are secure and information is clear.

○ Count physical entries, entries listed on the summary sheet, and entries listed in our records. Do all the numbers match?

○ Type check, master form (if required), shipping labels. Does check amount match the summary sheet information from the item above?

○ Double-check your work or have someone else do it.

○ Package entries carefully and securely for shipping. Use cardboard envelopes and plastic page protectors as needed.

○ After we receive notification:
update competition summary records
send information and/or fees as required by competition
send congratulations letter to client with certificate or plaque if available

AWARD LETTER

PROMOTE THE RESULTS

After you've won, you'll want to make clients aware of your success. Many winning firms send a letter to their clients, including such information as the name of the competition, how many other firms were selected and so forth. If duplicate awards certificates are available, you might want to include one with your letter, or perhaps a copy of the award annual itself. Here is an example of a letter notifying a client that work done on their behalf has received recognition.

December 29, 2000

Ann Carter
Carter Incorporated
1507 Dana Avenue
Cincinnati, Ohio 45207

Dear Ann:

The thirtieth annual American Advertising Awards (ADDY) awards banquet, sponsored by the Advertising Professionals of Des Moines, was held on December 21 in Des Moines. Smith Graphic Design was fortunate to be among those recognized for excellence in design and advertising.

I am happy to tell you that our work for Carter Incorporated won three first place ADDY awards in the Business Collateral category: one each for the 1999 annual report, capabilities brochure and sale catalog. The Carter Incorporated new packaging program also received a Citation of Excellence.

We were honored to have received a total of 47 awards, including the Best of Show trophy. This is only the first step for our ADDY winners—they will now be judged against other ADDY recipients from our four-state district. The winners from the district level then compete at the national level.

We feel it is you who have made these awards possible with your ongoing support and trust. Please accept our thanks, along with a copy of the event program and the enclosed framed awards certificates.

Sincerely,

John Smith

MEDIA RELEASE

PROMOTE THE RESULTS

For very special awards, you may want to send a media release to the business editors of local newspapers. Here is an example of such a release. (For additional information on developing media releases, see "Getting Media Attention" on pages 22–27.)

DISTRICT ADVERTISING GROUP HONORS SMITH'S WORK

(Des Moines, Iowa) At a recent district event in Omaha, the American Advertising Federation presented 14 awards to Smith Graphic Design and the work of John Smith.

Five projects won first place (ADDY) awards for three clients: Creighton University, James River Corporation and Java Coffee Bar. The Creighton University piece, "Imagine Yourself Here," also was the recipient of a Judges' Special Award for Excellence in Design and Concept, a one-of-a-kind award developed by the competition's jury to recognize the piece.

Citations of Excellence were given to projects for five Smith clients in eight divisions, including a sales kit for James River Corporation, brochures for Carter Incorporated, promotional materials for North Light Books, corporate identity for Acme Incorporated and additional pieces for Java Coffee Bar.

John Smith has won over 500 awards from organizations across the country and around the world. His work is also regularly featured in design books and trade publications. The Smith Graphic Design studio is located at 308 Eighth Street in Des Moines, Iowa.

FOR MORE INFORMATION
Jane Smith (319) 555-1212
or visit www.smithdesign.com

FOR IMMEDIATE RELEASE
December 2000

15

GETTING YOUR WORK INTO DESIGN BOOKS

In addition to awards annuals, many designers have found success having their work represented in trade reference books (like this one!). Scores of these books are published each year, and unlike the juried competitions described in the previous section, trade reference books generally have no submission fees. Those that do are often "capped" at a certain level, regardless of the number of submissions by a particular firm. Some creative professionals believe that the selection and inclusion processes for these types of books are more liberal than those for juried competitions.

Once a publisher has identified an author to develop a book on a particular topic, the author generally has authority about what work, firms and images are ultimately represented in the finished book. Topics for these reference books range from the general to the very specific, as well as from the basic to the advanced. A visit to the "design and advertising" section of your local bookstore will provide you with a good introduction to the world of trade book publishing.

Your next step in getting a book publisher and/or author to notice you is to get on the mailing list to receive notification of new opportunities as they arise. Jot down the publishers' names and addresses from the trade books you see at the bookstore or library. Call and ask who is in charge of acquisitions and add them to your mailing list. Write and ask

to receive "call for submissions" forms. You might also consider contacting individual authors directly, if such contact information is available from books they've already written. Many book authors also contribute to trade magazines, so if you're developing a list of contacts, you could also include the individuals who write magazine articles of particular interest to you and your area of specialty.

Once you receive a call for submissions and have something you want considered for publication, it will be important to take an organized, efficient approach to sending your materials. Publishers and authors operate on strict deadlines, and being late or incomplete reduces your chances for inclusion. Many times you'll be asked to submit a transparency of your work; this means you'll be expected to provide a professional-quality image. Look at the photographs included in trade books for guidance on how to arrange your work for publication and the best chances of getting in.

TIPS FROM EDITORS AND PUBLISHERS

• Sign and date the release form (usually incorporated into the call-for-submissions form). An author cannot reproduce your work without it!

• Have your work shot by a professional photographer. It doesn't matter how great the piece is if the photo isn't up to par.

• Be sure to provide complete and accurate creative credits when you submit your materials.

• If you are called for additional information, reply as quickly as possible. Deadlines are usually pretty rigid, and an editor may include someone else instead of you if the other person responds quicker.

CLIENT LETTER

PROMOTE THE RESULTS

Once the book is published, make sure your clients know your work (and their projects!) is included by sending a letter and perhaps a copy of the book, or a photocopy of the page where the project appears.

December 28, 2000

Jill Jones
Acme Incorporated
123 Main Street
Des Moines, IA 50310

Dear Ann:

Congratulations! North Light Books has released their new publication Get Noticed! and I'm pleased to tell you that our collaboration, "We Draw Circles," is included. We are honored to be featured in this exciting publication—only 195 projects were selected from the 2,000 submissions received from thirteen countries.

Enclosed is a copy of the book. Please accept it along with our thanks for the opportunity to work together.

Sincerely,

John Smith

BECOMING AN AUTHOR YOURSELF

Another option for getting your work and your name in print is to be an author yourself. If you've written and been published before, you know the rewards as well as the costs associated with this type of exercise. On the reward side is the ego-gratification of seeing your name in print. You'll also have an opportunity to meet some wonderful people and make contacts you might not have made otherwise. A successful book often results in invitations to do lectures and presentations around the country, and can help give a boost to any consulting work you are involved with. The flip side is that you'll probably have to sacrifice a lot of your personal time to finish your book, not to mention the fact that you will be surprised at how little authors of trade books are actually paid for their efforts.

You're probably smart to start by writing an article before you dive headlong into writing a book. Research trade magazines and request their guidelines for article submission. Review books like *Writer's Market* (Writer's Digest Books). Talk with other authors and ask how they got started. Many began very small, with articles for local newsletters, for example.

Often, a book publisher will approach an author whose work they know with an idea for a title. Much more often, however, books are developed because an author created a proposal that was submitted to—and ultimately accepted by—a publisher. Successful authors generally select topics they have knowledge of, thereby increasing their credibility. For example, if you are an acknowledged typeface designer, a book on developing typefaces might be an excellent vehicle.

A book proposal is typically three to six pages long, and may be presented in the form of a letter. The proposal should detail what the book is about, who the target audience is, its physical dimensions, number of pages, pictures or illustrations and words, competing titles, and who is going to write and/or design it. A clear, marketable idea is essential in getting a book proposal accepted. Even if it's a very visual project, a book is a printed medium, and being able to express ideas on paper is paramount to success. The most successful books are those with a "crossover" market and an international appeal. A catchy title also helps sell a book concept and, ultimately, the book itself.

TIPS FROM TRADE BOOK AUTHORS

• Consider finding a co-author to help make the process less daunting.

• Ask the publisher you want to approach for a sample book proposal or guidelines for submission.

• Read a lot—you'll get ideas from other authors that you can develop or expand upon.

• Realize that the process of writing a book is just like completing a project for a client. You'll need to be organized and able to adhere to a deadline. If these things are difficult for you, reconsider!

BOOK PROPOSAL

Tentative Title:	Self-Promotion Designs that Work for Graphic Designers
Author:	Sheree Clark / Kristin Lennert
Category:	Graphic design
Rights:	World
Imprint:	North Light
Color illustrations:	150
B&W illustrations:	45
Size:	8½x11
Total pages:	144
Binding:	Paperback
Price:	$27.99
Publication date:	Spring 2000

THEME

Detailed case studies of how specific designers, illustrators, photographers and small advertising agencies promote themselves. Includes a gallery of effective self-promotional efforts subdivided by type of promotion, e.g., direct mail, invitations, brochures and posters.

WHAT THE BOOK IS

This book gives the basics every design firm (as well as creatives such as photographers and illustrators) needs to start their business, get new clients and perhaps even make a name for themselves.

The first section will be a mini-course in self-promotion techniques, and will include little-covered but much in demand self-promotion basics, such as information on how to submit work to design competitions, how to write an effective press release, how to get your work international press, and tips from editors on how design firms can make an impression that gets them published in magazines and books. The second section will include detailed case studies of how specific designers, illustrators, photographers, and small advertising agencies promote themselves. The case studies will include examples of self-promotional pieces. The third section will consist of a gallery of effective self-promotional efforts (e.g., direct mail, invitations, brochures and posters).

WHO THE BOOK IS FOR

1. Designers, illustrators, photographers and small advertising agencies who could benefit from the effective use of self-promotion.

2. Other design and marketing professionals who are interested in promoting themselves or their organization.

KEY SELLING POINTS FOR ART STORE AND BOOKSTORE BUYERS

1. Self-promotion books are perennial in this market. There are always new people entering or returning to the field who need to promote their business.

2. The fact that the book was written by the principal and copywriter of a well-known design firm should garner this book interest with buyers.

KEY SELLING POINTS FOR READERS

1. Self-promotion is always a favorite, and coming from Sayles Graphic Design—a small Des Moines design studio that's known internationally by designers—this information will have automatic credibility.

2. While there are a number of self-promotion books on the market, this is the only one that includes such sought-after information as insiders' tips on how competitions are run and how best to get your work noticed, how to get international press, etc.

COMPETITIVE TITLES

Promo 2: The Ultimate in Graphic Designer's and Illustrator's Promotion, edited by Lauri Miller (North Light Books, 1992)

Best Small Budget Self-Promotions, Carol Buchanan (North Light Books, 1996)

Self Promotion Case Studies, Linda Cooper Bowen (Van Nostrand Reinhold, 1998)

Fresh Ideas in Promotion, Lynn Haller (North Light Books, 1994)

Creative Self-Promotion on a Limited Budget, Sally Prince Davis (North Light Books, 1992)

SECTION ONE:
The Nuts and Bolts of Self-Promotion

A general introduction to the art of self-promotion. Included will be narrative and visuals with step-by-step overviews of activities in three specific areas:

1. Getting the Attention of the Media
• writing a media release
• developing a database of editors
• developing effective visuals for the media
• how to follow up and when not to
• tips from editors and successful self-promoters

2. Getting Work Published in Awards Annuals and Periodicals
• competitions: how to submit, what judges look for
• book submissions
• becoming an author yourself
• tips from competition organizers and award winners

3. Self-Promotion Strategies
• special events (open house, moving, celebrations)
• working with a rep
• tips from self-promotional experts

SECTION TWO:
Case Studies

How some successful firms promote themselves. Including such information as:
• brief firm history
• early promotional efforts with commentary
• live examples of media release resulting in printed article
• databases: how to maintain, utilize, etc.
• color photos of self-promotional projects (could include shirts, mailers, posters)

SECTION THREE:
Gallery

A compendium of effective self-promotions from firms and professionals. Areas covered include invitations, posters, brochures, wearables, campaigns and

DEVELOPING A DATABASE

An effective database can make or break a self-promotion effort. It's critical to send information to the right person—if not, you're wasting your time, resources and ideas. A good database will include a variety of types of contacts: potential and current clients, vendors, the media and any special groups you want to promote yourself to.

MANAGING INFORMATION

Once you have a sense for the individual companies that you'll want to include on a mailing or contact list, the next step is legwork: making telephone calls to get names, titles, verify addresses, etc. Often you'll have the best success by simply calling the main number of the company you're trying to initiate contact with and asking a specific question such as, "Could you please tell me the name of the person in charge of your marketing and advertising?" You might want to think through other ways of asking for the information you want. Sample questions that can yield results include:

• Who is in charge of hiring outside designers (photographers, illustrators, etc.) for brochures?
• Who works with printers when you need something printed?
• Who is in charge of your annual report?
• Who is responsible for your trade-show participation?

Once you think you have the information you're seeking, take advantage of the opportunity to also do the following:

• Verify the spelling and exact title of the person.

• Verify the formal name of the company and its address.
• Get a "direct" phone number or extension; also ask for a fax number and E-mail address.
• Ask if there are other people in the company who you might also want on your list. For example, ask, "Does the director have an assistant who might also want to receive mailings from an illustrator?" or "Is there anyone else in the company who hires photographers for special projects?"
• Clarify exactly what the company does if you don't already know.

There is a vast array of contact-management software programs available to assist you in tracking the list you're developing. Spend a little time researching which programs will work best for your needs. You'll probably want a program with a variety of features—they can include fields for custom information or notes, template letters you can personalize, mailing label and envelope printing, even built-in alarms that help you remember when to call someone back. You'll also want the flexibility to note when a particular entry was last updated and the ability to sort your list by contact type. This means, for example, that you will be able to print labels for just the media contacts on your list when you have a media release to send, or that you can mail to certain cities or states that you select.

In addition to developing your own "from scratch" database of contact names, there are companies that specialize in maintaining and selling lists to the creative-services field. Some of these list brokers are associated with advertising trade publications; others are independent list managers. Most of the time, the

What you've just done is establish the beginnings of a database for your mailings and self-promotion contacts!

lists are available for purchase in a variety of ways, from one-time use of specific demographics to a buyout of an entire list itself. Brokers will generally offer you the option of a paper printout, digital copy of the list, labels or a combination; the addition of each option usually results in an increased fee. Even if you buy a current list from a reputable broker, you will be well advised to do a little tinkering with the list prior to using it. Scan the list for titles to be sure you're reaching the people who will be most helpful to you. Call a few random contacts to see that they're still with the company. Eliminate contacts from geographic areas that are not appealing to you for one reason or another.

ADDING TO YOUR LIST

In addition to the process of calling companies to add names to your database, be aware of these other sources for contacts:

• The news. Read the newspaper and look at other sources of business information with an eye to what it all means to you. For example, the "New Jobs" column can alert you to a new marketing director; the financial pages can tell you when a company is about to go public, which means they'll soon need an annual report. Train yourself to listen to news and think of how it potentially could affect *your* business relationships.
• Referrals. Some of the best clients you'll ever get will be a result of a referral from an existing client. Don't be afraid to ask your best clients to recommend you to someone else. This same philosophy goes for your vendors; ask

them to give you names of people who may need your services.
• Your surroundings. Buildings that are being expanded mean a business is growing. Increases in staff usually mean more is being spent on marketing. Watch for trends and be on the forefront!

KEEPING YOUR DATABASE USABLE

Once the initial work in developing your database is done, you'll want to keep it as current as possible. This means a regular, planned process of updating and maintaining your list. Most database managers recommend a systematic and complete review of your list at least annually, while others recommend a thorough updating every six months. Whatever your schedule, the process for updating is nearly identical to the procedure used in establishing the list: telephone calls to every company where you have a contact name.

TIPS FROM SELF-PROMOTION EXPERTS

• Keep your database clean. Misspelled names, wrong titles—these things can spoil even the most creative self-promotional effort.

• Spend time researching what different contact-management software packages can do for you. Call other creative professionals and ask what they use.

• Make updates to your list as you become aware of them. If a client gets a new title, or a telephone number changes, make the change in your database right away. Doing so will help keep your data as current as possible.

• If your software has a "notes" or "alarms" function, learn how to use it. Make it a practice to keep track of information you might want to retrieve later.

• Remember that a bigger database isn't always better. Purge your prospect list of those who are not bona fide potential clients.

GETTING MEDIA ATTENTION

In general, the term "media" refers to all sorts of media: from daily newspapers to periodicals to broadcast media such as radio and television. For our purposes, we will focus most of our attention on the medium of print.

An effective and low-cost way to get your name out is to be mentioned—or better yet, featured—in a magazine or other print publication. There are many ways for you and your firm to end up in print, but most of them require some effort on your part. The most basic and obvious way to become noticed by a newspaper, publication or periodical is to submit a news release (also called a press or media release). The challenge—and it can be a formidable one—is to have an "angle or a reason for a writer or editor to want to write about you in their publication.

Before we get into the nuts and bolts about writing a press release or how to approach the media, let's evaluate why some firms and individuals are successful at getting news coverage, while others are not. Most of the time it's a matter of appropriateness. To increase the potential use of information you provide, follow these basic guidelines for getting your message across.

STUDY THE PUBLICATION YOU'RE SUBMITTING TO

Every publication is different, and most of them—because they consist of sections—are almost like an assortment of publications. Before submitting your news, consider the characteristics of the different sections, then decide which best fits your information. In some instances, all releases will be sent to one person, often a managing editor.

It's a waste of time and energy to send news information to a publication that does not cover the type of material you're submitting. Take the time to review several issues of the publication you're seeking notice from. In addition to editorial content, note which publications include visuals, and in what form. For example, you probably wouldn't want to send black-and-white photos to a magazine that prints exclusively four-color images.

Most periodicals publish an editorial schedule or calendar—a map of what types of stories they'll write about over the course of a year—which can help you target the timing of your press release. Editorial schedules are free, and you can request them by phone or fax. Generally speaking, the schedule for a given calendar year is finalized the preceding October or November.

DEVELOP A DATABASE OF EDITORS

Not all proposed stories will have appeal to all readers. Because you've taken the time to study the publications you're submitting to, you will end up with a list of editors who are most likely to consider your news.

It's beneficial to keep a database of the editors and publications that may have

an interest in the stories you hope to have placed. Since you are in the creative services business, design and advertising-related magazines are a natural place to start, but you will also want your database to include other trade-press contacts as well as the general business press. As an example, let's say you just finished the design of a corporate identity and collateral program for a new restaurant. Naturally, design magazines will have a potential interest in the project, but in addition, you'll want to send your information to the local newspaper, restaurant trade publications, *and* any contacts that might have a particular interest in any of the players in the project. This might even include your own and your clients' alma maters and the newsletter or magazine of any organizations you belong to. And don't limit yourself to the USA: International publications are great additions to your contact list.

To develop your own database, try developing several lists of possible publications you can include. The following is an example:

General Design and Advertising Trade Press
Adweek
Advertising Age
Communication Arts
Dynamic Graphics
Graphic Arts Monthly
Graphic Design: USA
Graphis
HOW
Print
Step-By-Step Graphics

Specialty Trade Press
Design Journal
Packaging Digest
POP Times
Visual Merchandising & Store Design

Local Press
Your local daily newspaper
Your local business newspaper or magazine (it could be weekly like Crain's *Chicago Business*, or monthly like Kansas City's *Ingram*)

Personal Contacts
Your high school newsletter
Your college magazine
The publications of organizations you're connected with

Client Related
The trade magazines for the industry of any of your clients. Restaurants, health-care organizations, financial institutions, retail, etc., all have their own periodicals that accept newsworthy submissions from outside.

Business
Business Week
Fast Company
Inc.
Success

As with any database, your media list will need to be updated on a regular basis. An annual revision is an absolute minimum requirement.

WRITING AN EFFECTIVE MEDIA RELEASE

In most cases you'll need to present your information in writing—preferably submitted as a press release. Following are general guidelines for writing press releases, but remember that you must also become familiar with the publications you're submitting to, and take your cue from their articles.

Keep it short

One page is best, typed on 8½"x11" paper. Leave wide margins on all sides so the editor can make notes. If your release continues to a second page, type "more" at the bottom of the first page. At the end of the release it is conventional to type "-end-" or "###" or "-30-". A release should rarely exceed two pages unless it is about a major event.

Keep it simple

Get to the point. A good release gets to the point in the first sentence. Don't be overly clever or verbose. Remember when you learned about the "five Ws:" who, what, when, where and why? The five Ws still provide a good framework for writing an informative release.

Proofread carefully

It is inexcusable to submit inaccurate or faulty information to a publication. Your credibility is on the line!

Seek input

After you've written your release, show it to someone who knows nothing about the topic you're explaining. Ask them for comments—do they have questions that should be answered in the release? If so, make revisions to be more complete.

Include visuals

When it's appropriate to the nature of the release, include visuals such as photographs or transparencies. Don't ask the publication to return unsolicited materials such as photos, and be certain what you're sending is of the best possible quality.

Be timely

The best time to send a "news" release is when it's truly "news."

Avoid duplication

If you send the same release to more than one person *at the same publication*, list the names of all recipients at the bottom. This helps prevent duplication of efforts at the publication and signals that you understand their business.

Keep copies

Be sure to have a copy of your release on hand in case a reporter, writer or editor phones you for additional information. Also it's a good idea to keep a record of each publication you sent information to.

FOR IMMEDIATE RELEASE
April 6, 1998

Contact: **Christina Arbini**
Media Relations
(206) 467-5800/ext. 329
c_arbini@hadw.com

HORNALL ANDERSON DESIGN WORKS CREATES
SHARP MARKETING TOOL FOR LEATHERMAN

Seattle, WA—Hornall Anderson Design Works, Inc. (HADW) recently completed the design of the Leatherman Tools 1998 Product Catalog. Leatherman Tool Group, Inc.—a Portland, Oregon based manufacturer of compact, multi-purpose tools—approached HADW with a need for a product catalog to represent their eight models of tools.

HADW and Leatherman joined forces to create a marketing piece that would fuse together the abstraction of the Leatherman tools' technical attributes with the natural conditions in which they are used. Emphasis on the tools' precision quality was depicted through actual product photography, partnered with illustrations describing resourceful usage of Leatherman tools.

The catalog design's industrial architecture and jargon couples with creative "Tool Tales" testimonial copy, yielding a look and feel reminiscent of a "weathered" and "worn" travel journal.

1008
Western Ave
Suite 600
Seattle, WA
98104

206 467 5800
FAX 467 6411
www.hadw.com

Encl.: Reproduction quality slide of Leatherman Tools 1998 Product Catalog

HORNALL ANDERSON DESIGN WORKS

Follow the established format

On page 25 is a sample of an actual release from Hornall Anderson Design Works that was submitted to publications including *Communication Arts*, *BrandWeek*, *Graphic Design: USA*, *Critique*, *HOW* and local newspapers including the *Puget Sound Business Journal*. Notice that the release includes an attention-getting headline, all the pertinent details and contact information, and contains no typographical errors.

What to write about

There are a number of types of releases that are appropriate to submit to a given publication. Of course, you'll want to tailor what you're sending based on the content, style and audience of your target publication. Following are a few ideas.

Feature pitches are among the most difficult types of stories to get placed. There is a lot of competition for the limited amount of feature space in any issue, and the publication naturally wants to include firms or individuals with the most to show and tell about. A feature release or pitch should paint a broad picture of what makes you unique and newsworthy. It might be written in the form of a query letter, and could include background information such as company history, as well as sample visuals, such as transparencies or samples of the firm's work.

Project releases are simple and timely, providing a way for you to show "what's new." For these releases you'll want to select a project with potential for some interesting narrative. Examples of good candidates for a project release include:

• "Makeovers." A "before and after" can have interest to a variety of audiences. In this case it probably makes sense to send samples and/or shots of both the old and new identity, package or design.

• Big name client. Whether you like it or not, when your clients have recognizable names, you sometimes have an edge in the media-placement game. Play up your best work for those heavy hitters!

• Design innovation. If your latest project features some sort of design innovation such as a unique binding material or an unusual photo technique, you have a good chance at some trade mention. Whenever possible, send an actual sample to allow the editor to see the technique you talk about in your release, but don't ask to have the sample returned to you if it's being sent unsolicited.

Sometimes your liaison with a client has potential appeal to the business press, so you might write a business angle news release. This might include your work with a startup business, or an unusual fee arrangement, where in exchange for your services you hold a stake in the business. If you read your local business papers with an eye to the type of stories they run about business dealings and transactions, you'll find plenty of ideas for angles.

If your own firm has an interesting type of business operation or partnership, it could also be newsworthy. For example, if your business is owned by a husband-and-wife team, or you have an unusual management arrangement, you could also attract media attention.

Another option is the personal interest release. What do you do in your free time? How does it relate to your business? Many publications include lifestyle and personal interest stories in their mix of editorial. (For an example of a design firm that has used this form of promotion successfully, see the feature case study of Sayles Graphic Design on page 50).

Following Up

Most editors agree that extensive follow-up to a release or feature pitch is not necessary, preferring a "don't call us, we'll call you" approach. "I get so many releases in a week," says one editor, "that if I had a follow-up call for each one I'd never get any stories assigned!" Another editor states: "One firm includes a business reply postcard with her releases. This lets me send a note to them quickly and easily. Sometimes I ask for more info, and other times I tell them I can't use their stuff. Either way, they know where they stand."

TIPS FROM EDITORS

• Know our publication and whom we target! I can always tell when I get a release from someone who isn't familiar with our magazine.

•Instead of thinking about what you need to say, ask yourself, "What does the editor need?"

• Don't hide information. You have one paragraph to tell me what I need to know. If I'm interested I'll read on. But get all the important facts out first.

• Appearance matters! Use good paper. Provide crisp photography (or tell me where I can get it).

• Send me a sample along with the release when you can.

•If you're sending E-mail, keep it short. The same goes for phone calls, particularly those asking me if I received a release.

• Know the medium you are approaching. Don't assume a daily general interest newspaper will want the same information as a TV news director.

28

USING OUTSIDE CONSULTANTS

WORKING WITH A REP

Reps represent you to potential clients. Photographers, illustrators and other creative professionals have long used professional reps with much success. One of the advantages of working with a rep is that you can have a presence outside your own market. While some representatives work within one region, many cover a national territory. You will need to sign a contract with the rep, and give them exclusive rights to a specific area. You may have more than one rep, assuming their geographic areas of service or territories do not overlap.

Reps devote all of their time to generating business for the creative people they represent. Your rep will respond to an inquiry from a potential client, negotiate the contract for the work and generate billing after the project is completed. They generally work on a percentage of the revenue they bring in (often from 20 to 30 percent, depending on your arrangement).

You will be most desirable to a rep if you have a reputation for being professional and dependable. Your work should be compatible—yet not compete—with the work of others the rep already represents, and it's best if your work is somehow unique.

There are some up-front costs you will incur when you begin a relationship with a representative. Initially, you'll need to prepare a portfolio for the rep to use in promoting your work. In addition, you will usually be expected to pay a portion of the costs of any ads, mailers or promotions the rep puts together for the group of creatives the rep generates business for.

Keep your rep up to date on your current work. Add them to your mailing list. Giving your rep as much information as possible about you and your work will help them promote you better.

WORKING WITH A PUBLIC RELATIONS FIRM

Public relations people spend their time representing their clients' interests, frequently with the media. They will work to make you more visible in the public eye by doing such things as writing press releases or contacting journalists to try and get you featured in appropriate news stories. Public relations professionals also can help you with your entire marketing program, including self-promotional mailings.

Public relations firms generally charge an hourly rate for their services, whether or not their efforts result in media coverage. You can help manage the costs of doing business by being organized. Assemble a file of your previous self-promo efforts to help make the orientation process shorter.

Your selection of a public relations consultant or firm is an important one. You may want to align yourself with a firm of comparable size to your own business, and you'll also want to find people with an understanding of the field of creative services. Evaluate whether it's better for your media releases to be sent out on your letterhead or your PR firm's. The answer will often depend on the content of the individual release.

Special occasions can be wonderful self-promotion vehicles, because they give us a reason to communicate. Whether you've moved your office, hired new staff, won awards or given birth to a child, you have an excuse to initiate contact with those people you have on your list. Other less intimate special occasions such as Thanksgiving or other holidays also provide us with a handy "theme" that any other communications would not have.

The most important guideline in special event promotions is to be timely. We've all received Christmas cards after the new year has begun, and we generally are left with the impression that the sender is unorganized. Likewise, an announcement that you've won awards or achieved some other success should come relatively soon after the fact.

If your announcement is to be combined with an event, you'll need to plan advance notice to allow the people receiving your invitation to make plans to attend. Depending on the type of event and the time of year, up to three weeks notice is appropriate. The invitation will set the tone for the event itself, so take time to think through how you want the event to be perceived. Will it be fun and casual? Businesslike and serious? The invitation should tip off the recipient as to what to expect.

If your event is a public one—and you're willing to allow people other than those on an established list to attend—you might consider sending an announcement to the media (see the section on media relations). If the event is not public, you still might want to send out a press release after the fact.

The event itself will also require a bit of forethought in order to make it as beneficial promotionally as possible. Details such as where guests will put their coats, providing nametags, and greeting people as they enter determine the success of an event. It might also be in your best interest to consider some sort of brief presentation about your company, or perhaps have "giveaways" or promo pieces on hand for guests to take away with them.

USING SPECIAL OCCASIONS

Let happy clients "sell" your prospects. Encourage your clients to talk about the successful projects you've completed together!

ou see their names every-where—trade publications, design books, even the local newspaper. And each time their name pops out, you ask, "How do they do it?" Every firm that gets noticed does so with a variety of successful promotion techniques. From cutting edge digital technology to tried-and-true newspaper coverage, there's no end to the possibilities. The following firms—all well regarded in the creative world—share their know-how and offer tips to get you on the road to recognition.

- **Hornall Anderson Design Works**

- **Ana Couto Design**

- **Johnson Design Group**

- **Curry Design Group**

- **Mires Design**

- **Eymer Design**

- **Sayles Graphic Design**

- **Kimberly Baer Design Associates**

- **Scott Hull Associates**

- **McCullough Creative Group**

- **Supon Design Group**

- **Visual Asylum**

- **Winston•Ford Design**

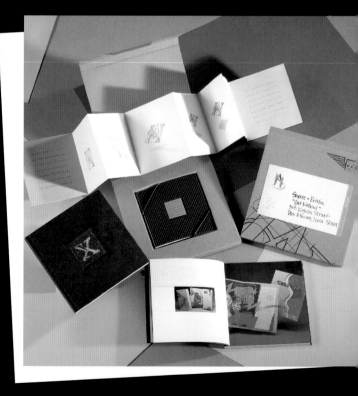

SECTION

CASE STUDIES

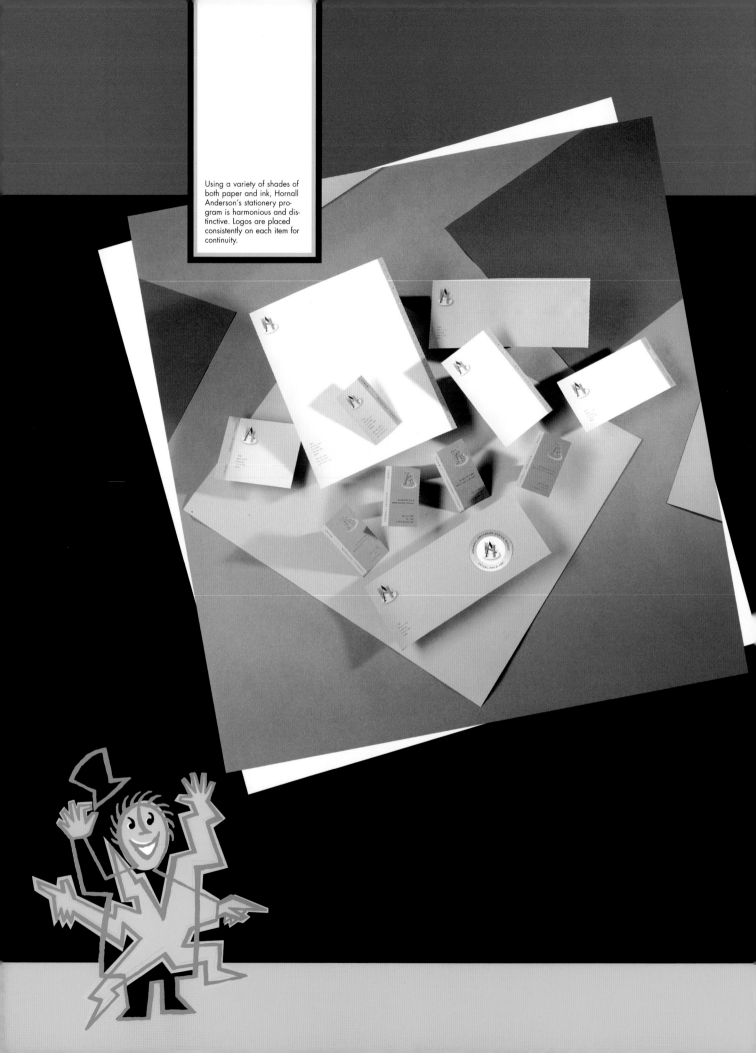

Using a variety of shades of both paper and ink, Hornall Anderson's stationery program is harmonious and distinctive. Logos are placed consistently on each item for continuity.

HORNALL ANDERSON DESIGN WORKS

prospective clients can "read all about it" ● when you focus on media relations

One thing is certain: When someone reads about Hornall Anderson Design Works in a trade magazine or design book, it's no accident. The firm's approach to self-promotion is as strategic as its work on behalf of clients like Airborne Express, Holland America Cruises and Starbucks. Because of the company's commitment to public relations, a promotion from Hornall Anderson always hits its mark.

As with any creative group, Hornall Anderson started promoting its business as a means of educating potential clients about the firm's services. "We view self-promotion as a way to differentiate ourselves from the competition," says studio principal Jack Anderson. Partner John Hornall agrees: "Not only does effective promotion bring exposure to your company, but if done well, it will also contribute to the growth of your overall client base." Since founding their firm in 1982, Hornall and Anderson's mission has remained the same: to approach every job with solid expertise and fresh enthusiasm, to give clients design solutions in tune with their marketing objectives, and to strive to elevate every project above the ordinary. This mission has also driven every promotional move they've made.

Both principals actively participate in promoting Hornall Anderson, along with Media Relations Manager Christina Arbini, who is responsible for implementing the firm's strategic promotional plan. "We incorporate a wide variety of approaches," says Arbini, who has been with Hornall Anderson since 1993. "In many ways, each effort has become something that builds our name and reputation outside of our own marketplace. We're well known in Seattle, but someone outside of the Pacific Northwest may not be as familiar with our work. A successful campaign will introduce your firm to prospects around the globe," Arbini says.

For Hornall Anderson, the promotional mix includes issuing media releases on topics including announcements of newly acquired business and awards won. "It's important to target your message to the particular audience you want to reach. For instance, new client or project announcements should be directed toward trade publications specific to your or your clients' industry," Arbini emphasizes. Her expertise in media relations allows her to work closely with many members of the trade press, and when appropriate she develops press kits that include the firm's history, biographies of the principals, extensive client and award listings and article reprints. Arbini pitches in-depth features on various design projects to design-based national and international publications, and also looks for opportunities to write articles on individual disciplines of the firm's work that focus on a specific business or industry. "I use different angles to promote Hornall Anderson and our clients to the media, which results in increased interest and exposure," she says.

Arbini has also found that direct mail is a proven vehicle, so she puts the Hornall Anderson staff's variety of talents and depth of experience to work creating dynamic mailings and promotions that include press clippings and reprints of

34

TIPS FROM JOHN HORNALL AND JACK ANDERSON

• Decide up front if you want your promotion to be seen by a wide assortment of people or a very specific group.

• Target your promotion—whatever it may be—to the audience you want to reach.

• Provide sufficient visuals and copy to support your targeted promotions and press releases.

• Continue to research new outlets for your promotions—additional print sources, radio and speaking engagements.

• Track the expense of your promotional mailings and press releases to gauge their success and benefits.

• Be timely in your response to inquiries and provision of materials.

• Be frequent and be consistent!

articles about the firm. "We use article reprints in self-promos, which generates more credibility with our audience," says Arbini. "And we send out mailers frequently and consistently—two things that are important for anyone doing promotions."

Hornall Anderson takes its own advice: Its mailers are as innovative and exciting as the work the firm does for clients. Arbini says the firm also turns individual mailers into more substantial promotions. For instance, the theme of an invitation to the company's ten-year celebration was carried over into a compendium of the firm's best work over the decade. "The party was certainly a great way to celebrate our success. And the book that every guest took home put a significant amount of our work into their hands. The format is something that they will keep and review in the future—perhaps when they are in need of a design firm!"

Most promotional pieces that Hornall Anderson develops incorporate the earthy, natural look that is part of their corporate image. Arbini says that it's important that a promotion be easily identified as coming from Hornall Anderson, otherwise the recognition—and the overall effect—is lessened.

"The impact of self-promotion on our business has been phenomenal," Arbini reports. Not only has it created an awareness about the firm at an international level, but it has increased the interest that potential clients have in working with Hornall Anderson, resulting in many inquiries about the firm's capabilities. Arbini says, "Whether you prefer to use general media releases or strategically placed feature articles, we've found that we get the best results when we are consistent in the methods and timing we use to achieve exposure for our company and its work."

A wire-o bound booklet provides a thorough introduction to Hornall Anderson Design Works. Included are biographies of the firm's principals, a mission statement, magazine reprints, a listing of services, client references and a listing of awards won.

Hornall Anderson's frequent use of media releases has resulted in coverage by publications of all types.

A sixteen-foot display of the Roman numeral ten incorporates the X theme of Hornall Anderson's tenth anniversary. The textured, faux-painted expanded polystyrene is printed with credits and thanks to those who provided services or products for the anniversary event.

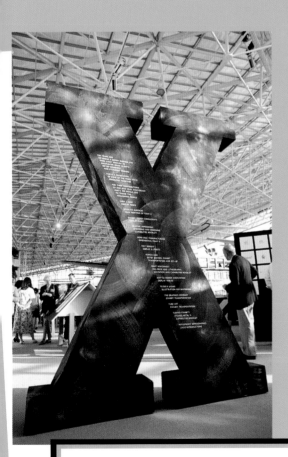

A series of three-dimensional mailers promotes Hornall Anderson's online department and familiarizes prospects with the company's Web site. A printed "message in a bottle" includes the Web site address, while another mailer contains a message delivered in a tin can (with opener). A unique holiday mailing incorporates one of HADW's client's products.

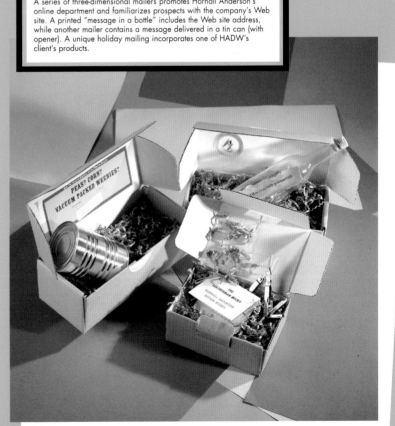

ANA COUTO DESIGN

identity

with

impact

GET NOTICED!

"Self-promotion is the essence of what a designer should do: communicate. If you can't communicate with your own design, how can you expect prospects to trust your ability to do it with their projects?" This philosophy guides Ana Couto's promotion for her namesake design studio in Brazil. Positioning her firm not just to be remembered, but to be the preferred design studio in the country, she developed a memorable and bold corporate identity. Vivid orange and green tones line the inside of Couto's envelopes and brochure, while a typographically diverse pattern of the words "graphic design" is printed on the outside of each item. Letters are presented in folders, mailings are enclosed in silver Mylar envelopes, and a dynamic corporate portfolio stands out with a spotted UV finish and a metal frame binding. The professional, aggressive nature of the message is clear, and in the end Couto's strategy has worked: The firm achieved an incredible 200 percent growth in just two years.

TIPS FROM ANA COUTO

- It's important to identify the essence of your best work in each promotion.

- If you get a good response to a promotion, you're in people's minds and should continue marketing yourself to stay there.

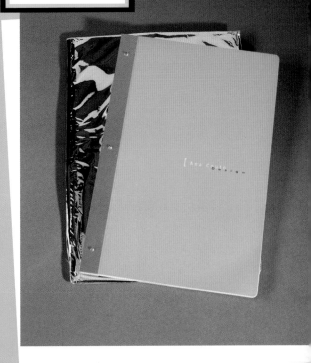

A metallic foil envelope protects the firm's oversize brochure.

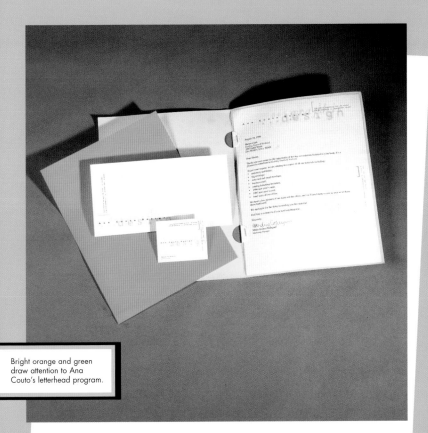

Bright orange and green draw attention to Ana Couto's letterhead program.

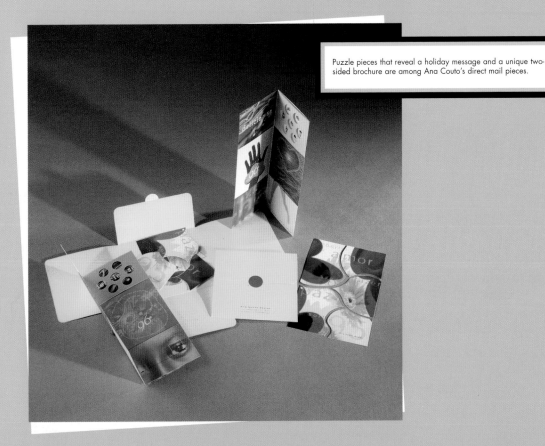

Puzzle pieces that reveal a holiday message and a unique two-sided brochure are among Ana Couto's direct mail pieces.

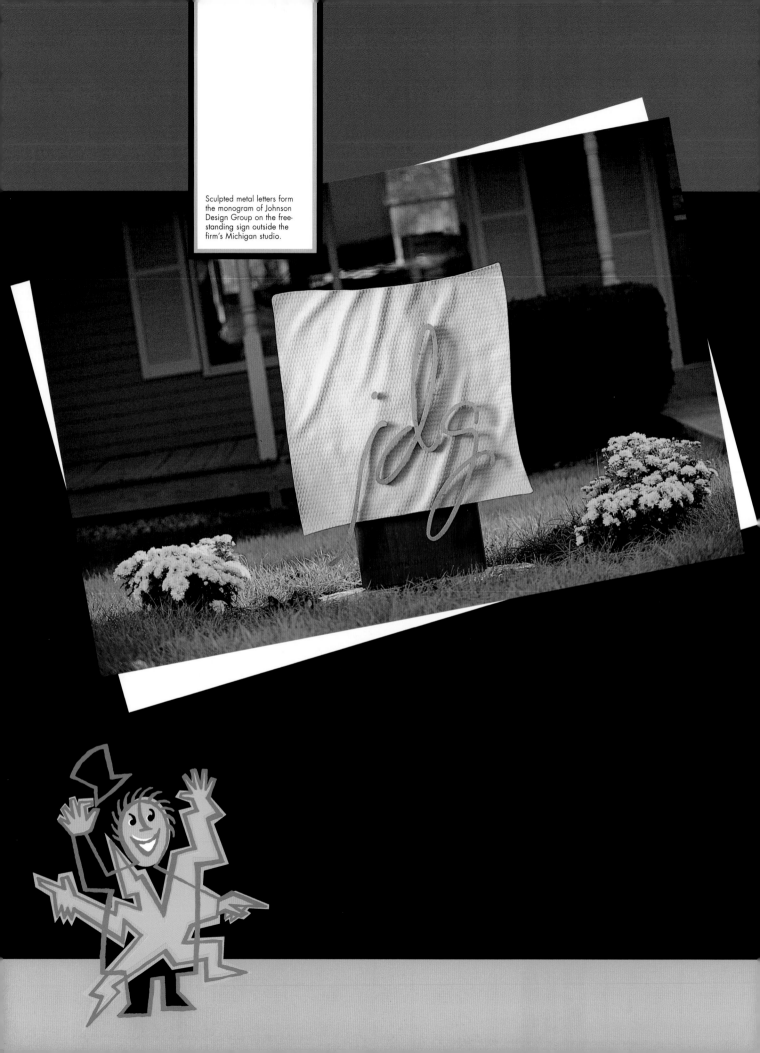

Sculpted metal letters form the monogram of Johnson Design Group on the free-standing sign outside the firm's Michigan studio.

JOHNSON DESIGN GROUP

When looking for a unique angle with which to promote Johnson Design Group, designer Karen Johnson identified two things that she deemed important—her sensitivity to organic materials and her Swedish ancestry—and found a way to make them work together.

When Johnson moved her namesake design studio to a riverside site in Michigan, she took advantage of the opportunity to redesign her building, corporate image and promotions with an eye to nature and heritage. With the help of a Swedish carpenter, Johnson transformed a one-time fly-fishing shop into a European-style cottage, outfitted with hand-crafted furnishings and state-of-the-art equipment. "We wanted a big space to facilitate working as a team," Johnson says. The result is a large, open area with light maple workstations that wrap around the room. "Light and clean with lots of natural materials—our approach to the building is no different than our approach to design," Johnson says.

The firm took inspiration from the dominant use of wood inside the studio and incorporated the substance into their stationery and collateral materials: Wooden pieces are added to mailings, presentations, and even business cards are thin wood. Johnson's use of the material was a natural: "It's important to me that our promotions reflect our personality, and the fun and excitement that design brings out in us." Johnson's commitment to self-promotion includes a strategic plan and an annual calendar of competitions, media releases and direct mail implemented by the entire staff. "Sometimes it can be hard to stick to the schedule, but it's definitely worth it," she reports. "When you get an overwhelming, positive response from your target audience and the design community, you've created exposure and awareness that will help generate new business."

Part of the attention Johnson Design Group receives is generated from the studio's consistent use of wood. During the initial meeting with a new client, Johnson presents a ¹⁄₁₆" wooden business card laser-cut with the firm's script monogram and mission; the back side is engraved with traditional contact information. The card is flexible but substantial, sure to stand out in any Rolodex. It fits snugly into a folder made of single-wall corrugated, another material Johnson uses frequently. The front and back covers of a three-ring presentation binder are corrugated, trimmed with a wooden Johnson logo and filled with a thorough overview of Johnson Design Group and its capabilities. Book-style corrugated wraps protect small wooden promotions in the mail. Even shipping boxes are knotty pine with a corrugated and wooden return address panel. Johnson Design Group's use of these items is a reminder that incorporating unexpected and non-traditional materials into mailers and other printed pieces can reflect the ingenuity and personality of the firm.

Even when the use of wood seems impractical, Johnson finds a way to make it work. For instance, the cover to a calendar is printed on a paper-thin wood, allowing the texture to show through. The project also relied heavily on her personal heritage. Called "Little

use
of
a
nontraditional
material
●
sets
this
nontraditional
design firm
apart

40

TIPS FROM KAREN JOHNSON

• Update your mailing list annually, or more often.

• Showcase your best creativity and talent: Be Unique, Original and Memorable.

• Collaborate with other creatives: printers, writers, photographers, paper companies.

• Map out a strategic annual marketing plan, and stick to it.

• Design a studio or work environment that's inviting, creative and a reflection of your statement as a professional design firm.

• Stay fresh and sincere, and strive to make a lasting impression.

• Keep asking yourself, "What do I want, and how am I going to get it?" in your personal and professional life.

Things," the calendar includes pictures of Johnson's Swedish family, taken in the 1800s and deepened in meaning with the addition of expressive quotes. "We gave these away at an open house in our new location; both the calendar and the party were a huge success," Johnson recalls.

One of the most effective annual promotions for Johnson's firm is the Christmas greeting. Created months in advance of the holiday, the studio's reputation for original and unique Christmas promotions has gained an overwhelming response. She credits an average of six months' of new business from the annual mailings, which include tokens made from the same wood as the studio's other signature promotions. Each year's greeting features a holiday message and a wooden keepsake, including laser-cut tree ornaments trimmed with leather and stand-up Christmas trees.

In recent years, Johnson has expanded her promotional activities to include local and national awards competitions, co-promotions with paper companies and photographers, and a variety of speaking engagements. The firm is also dedicated to pro bono work: "When you give back to the community through non-profit work you feel passionate about, those organizations have a real sense of commitment to you as a partner," Johnson emphasizes. "You can also end up with a variety of new work opportunities," she adds.

"Whether it's a holiday card, a special event or something else entirely, our main objective with every promotion is to generate new business," Johnson says. "Just as our work for our clients increases their visibility and market share, projects for Johnson Design Group must do the same thing."

Flowing lines and open spaces create a welcoming feeling in Johnson's studio. "Our staff unanimously opted for this type of layout," says firm principal Karen Johnson. "It contributes to the feeling of teamwork which we enjoy."

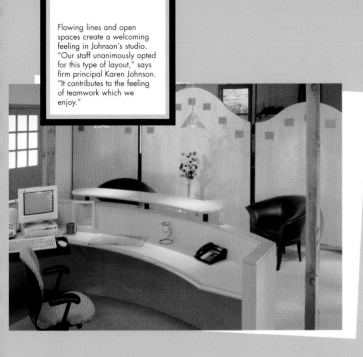

The earth tones, diverse paper colors and unique shapes in Johnson Design Group's current stationery are inspired by the company's new offices.

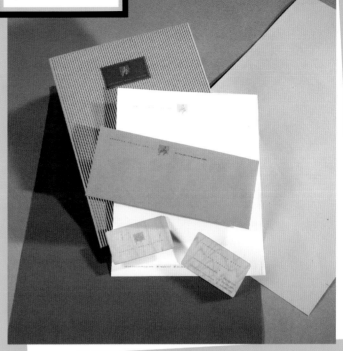

The front and back covers of a traditional three-ring binder are covered in corrugated and lined with canvas, providing a textured home for Johnson Design Group's corporate overview. The firm also transformed paper-thin pieces of wood into covers for a calendar, presented to guests at an open house. Johnson uses wooden crates rescued from a wine shop for an attention-getting shipping box.

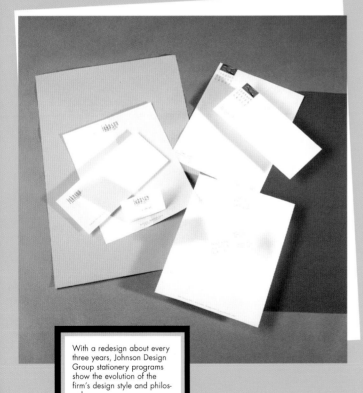

With a redesign about every three years, Johnson Design Group stationery programs show the evolution of the firm's design style and philosophy.

CURRY DESIGN GROUP

holiday

wine

promo

●

Every year since 1988, Steve Curry has orchestrated a memorable way of thanking clients and vendors for their support. He designed a special label for wine bottles, packaged the vintage in wooden crates and presented the gift in person. By Curry's account it was a "wildly successful" promotion; people still remember that initial bottle of wine. "We receive a lot of calls for them, and there is always a 'buzz' for the next year's piece," Curry says. He has done the wine promotion every holiday since, adding a calendar to the studio's highly anticipated gift list in recent years. Throughout the year, Curry works closely with staff marketing director Robert Taylor to strategically position his firm. Their projects include traditional brochures and print collateral as well as digital and Web site portfolios. "Promotion has helped us build a client base and develop awareness of our firm and its talents," Curry says. And there's little doubt that those clients look forward to each holiday season!

TIPS FROM STEVE CURRY

- If you want to be successful, continually and consistently promote your talents.

- Use different forms of promotions: holiday gifts, corporate portfolio promotions, etc., to show your range of abilities.

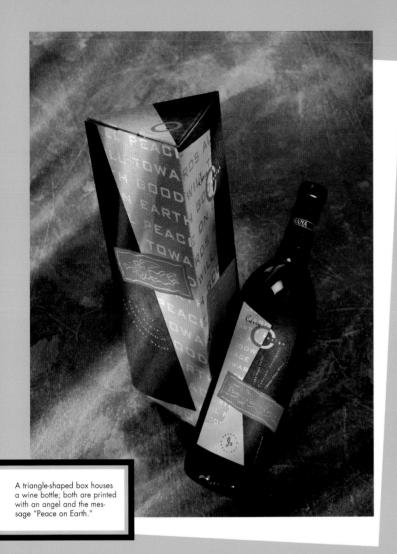

A triangle-shaped box houses a wine bottle; both are printed with an angel and the message "Peace on Earth."

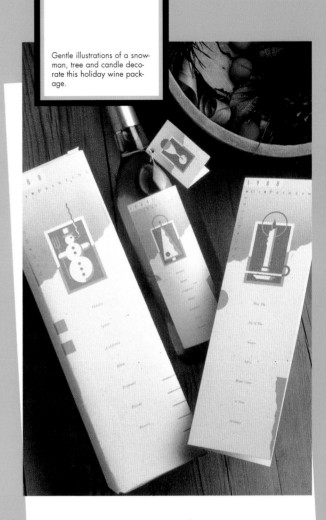

Gentle illustrations of a snowman, tree and candle decorate this holiday wine package.

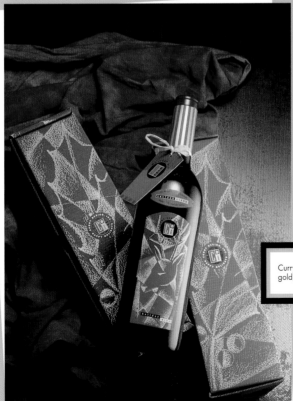

Curry's 1993 holiday wine promotion was packaged in warm gold, green and red.

Included in the online promotion are client case studies and an overview of the firm and its philosophy.

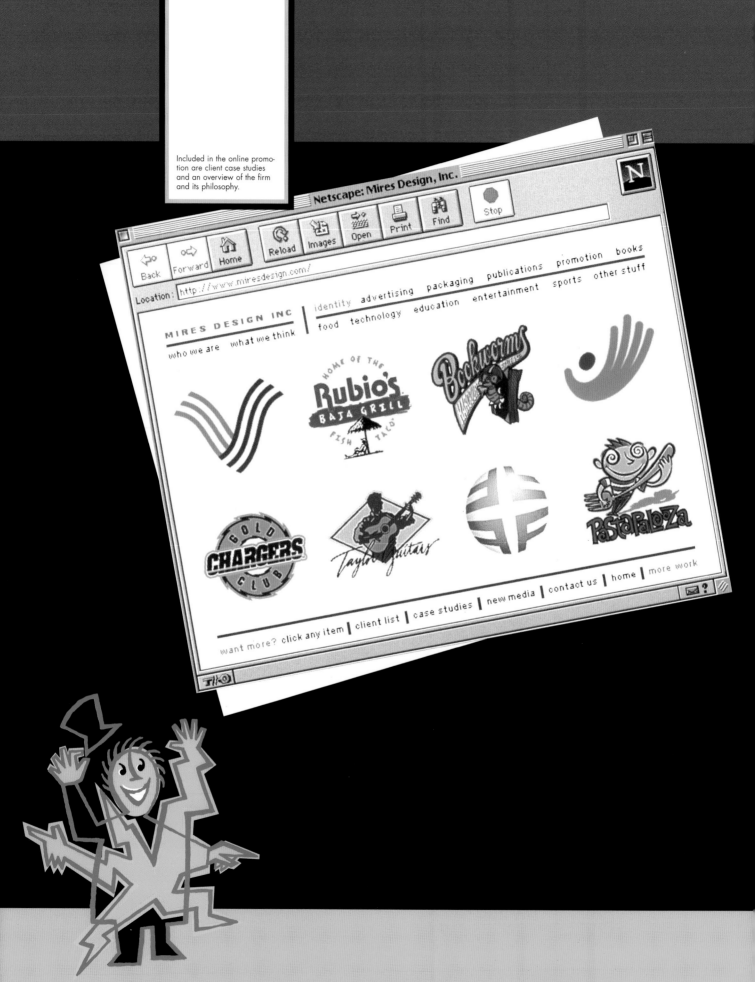

Netscape: Mires Design, Inc.

Back Forward Home | Reload Images Open Print Find | Stop | N

Location: http://www.miresdesign.com/

MIRES DESIGN INC

who we are what we think

identity advertising packaging publications promotion books

food technology education entertainment sports other stuff

want more? click any item | client list | case studies | new media | contact us | home | more work

MIRES DESIGN

Dara Williams, marketing manager of Mires Design in San Diego, says, "You never know when the right person will see something your firm did and try to contact you." But rather than wait for chance, Mires Design's self-promotions lead prospective clients directly to the firm's Web site to enjoy a carefully crafted online promotion.

Nearly 25 percent of the marketing Mires does for itself focuses on the company's Web site. Firm principal Scott Mires says, "We developed the Web site as an online portfolio, responding to national and regional interest in our studio. It allows potential clients to see our work immediately." The studio also uses the site to show project prototypes to clients and walk through the design process with them. "The site has really allowed us to reinforce the 'Mires Design' brand and showcase the quality of our design," Mires stresses.

Mires and co-principals John Ball and José Serrano develop an overall marketing strategy for the firm's promotions before handing off to Williams. She maintains Mires's portfolio and database of contacts as well as executes all public relations activities, competition entries and direct mail campaigns. That strategy has included several efforts specifically targeting Mires's Web site. One mailing is a simple black-and-white postcard to drive traffic to the site. Another more elaborate promotion involved several steps, with prospects receiving an invitation to visit the Web site and register to receive a T-shirt. The shirt's hangtag doubled as a message from the firm, and

Mires included a letter personally thanking the now-prospective clients for visiting the site.

Mires's philosophy for the Web site, and for all promotions, is simple: "We try to market ourselves with the same discipline we'd use to promote a client." This has proven to be a successful approach for the firm, whose focus on brand identity is part of promotions for themselves as well as their clients. They call it the "brand-centered approach" to design, and the words show up frequently in the studio's mission and marketing materials.

The firm has given careful attention to developing the Mires brand, and works to position themselves as a shop with specialties in a variety of areas, including identity and packaging. To that end, several individual brochures were created to address each of these areas. Packaging projects are showcased in a wire-o bound booklet with corrugated covers; a coordinating piece focuses on brand identity, including logos for such diverse clients as Nike, Caboodles, Harcourt Brace Publishers and the San Diego Chargers football team. In addition to presenting the work in a tactile and memorable format, Williams saves time by having a "stock" portfolio available. "This simple format shows our breadth of identity experiences and has been helpful in positioning us as an identity firm," Williams reports. The idea proved so successful that Mires developed a series of the logo books, each with a different cover graphic. They are sent to prospects and clients, and Mires says, "The logo books—we've done three so far—are among our most memorable self-promotions."

GET NOTICED!

online promotion results in ● awareness and new business

46

TIPS FROM SCOTT MIRES

- Focus your promotions on what you do best—don't try to be everything to everybody.

- Don't use just one method of promotion; try a variety of media.

- Tell your audience what problems you can solve and what benefits you deliver.

- Keep your message simple.

- Allow your promotions to differentiate themselves, and capture the heart and soul of your company.

- Give your audience a reason to respond—more information, a cool promotional piece, or some branded memorabilia.

- Be consistent—one piece every other year won't cut it. Make sure someone in your firm is responsible for executing a timely promotional effort.

- When responses from your promotional efforts begin to come in, call back promptly—a face-to-face capabilities presentation is optimal.

- Don't bite off more than you can chew. Too much work and missed deadlines can sometimes be worse than not enough work at all.

Another carefully strategized promotion is the client case study. The hardbound books approach one inch in thickness and offer a step-by-step view of the process that Mires projects take from concept to completion. The easy-to-follow format includes media releases about the product or communication challenge, memos between client and design studio, copy concepts, thumbnail sketches, promotion ideas and even meeting notes. "The case studies allow us to exhibit the depth and attention to detail we give each client and project; they are an effective marketing tool," says Williams.

Williams says she also uses ads and public relations to promote awards and general awareness within the industry and the business community, and it has had a positive impact on business. With a promotion of some sort nearly each month, Williams's hands are full implementing a wide variety of marketing projects that have included a series of direct mail postcards, moving announcements, holiday cards, special event invitations and case studies. Williams also remembers some less-than-successful promotions from the studio's very early years. "They were mostly conceptual and didn't show much of our work. We got a limited response." She now includes at least one work sample in every Mires promotion, no matter which medium is used.

At every phase of his firm's promotion, Scott Mires steps back and asks the same questions he asks about work for the studio's clients: Is the message clear? Does it cut through the competitive clutter? Is the Mires brand identification strong? Does it connect in relevant ways to the lives of the target audience? When the answer to each question is yes, Mires knows that his firm's marketing is making a name for itself—online and off.

Noteworthy Mires projects are given special treatment in unique case study books developed by the firm. The detailed step-by-step overviews give prospective clients an idea of the care and attention they would receive as a Mires client.

A custom T-shirt was a promotional gift for those who visited www.miresdesign.com during a limited time period. Entitled "Endless Summer," the message of the promotion was reinforced by a hangtag on the shirt. Nearly 4 percent of those who received letters of invitation and postcards from the firm visited Mires's Web site and got a shirt during the eight-week promotion.

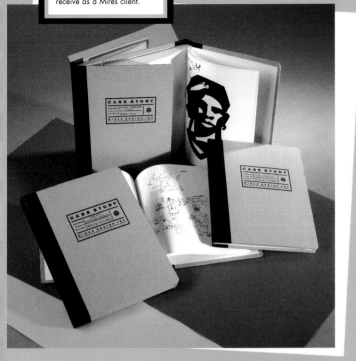

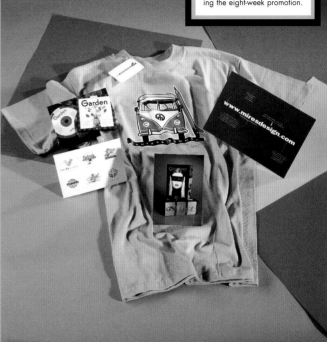

Since 1995, Mires Design has donated turkeys to area homeless shelters at Christmas time. The firm's Christmas card communicates seasons greetings and announces the donation.

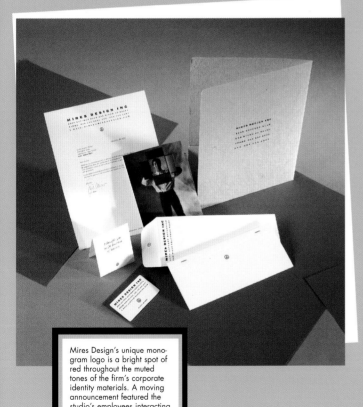

Mires Design's unique monogram logo is a bright spot of red throughout the muted tones of the firm's corporate identity materials. A moving announcement featured the studio's employees interacting with corrugated boxes.

EYMER DESIGN

premium self- promos

GET NOTICED!

Although they haven't actually sent one to clients yet, Eymer Design wants to be the "squeaky wheel" in each prospect's memory when it comes to design firms. Their lively use of premium items makes their memorable promotions stand out: a watch proclaiming "Stand Up, Be Noticed" on its face reflects studio principal Doug Eymer's philosophy on self-promotion. "Nothing feels better than walking into a prospect's office and seeing an Eymer Design desk calendar or secret agent pen," says Eymer. "It is at that moment that you realize that you already have two feet through the door—and that one extra foot separates you from the competition." The firm has incorporated thermos bottles, metal thermometers, writing devices, cigarette lighters, T-shirts, hats, wall clocks, calendars and commuter mugs into humorous mailings. "When people call each year asking if a new promo has gone out, you know you've made an impact," Eymer says.

TIPS FROM DOUG EYMER

• You don't have to spend a lot of money on self-promotion; a normal, off-the-shelf item that's packaged in a clever manner can be very effective.

• When you're starting out, you probably have a lot more time than money—use your own ingenuity and cleverness, and have fun. You should be your own favorite client!

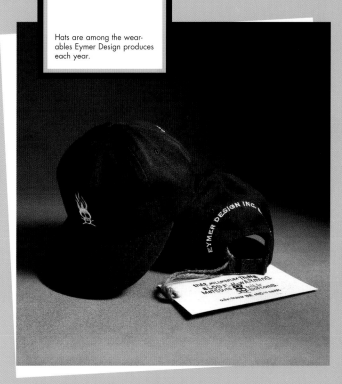

Hats are among the wearables Eymer Design produces each year.

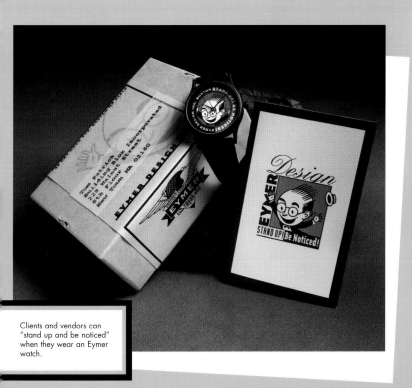

Clients and vendors can "stand up and be noticed" when they wear an Eymer watch.

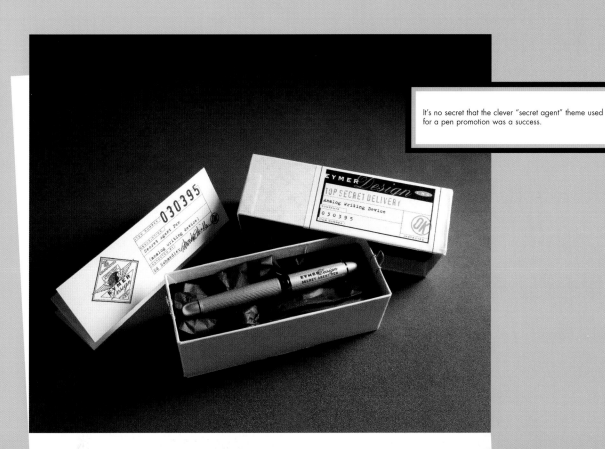

It's no secret that the clever "secret agent" theme used for a pen promotion was a success.

The poster series for the Miami Modernism art show and sale is among John Sayles's most recognized deco-inspired work. The entire series received a number of awards as well as nods of approval from deco collectors everywhere.

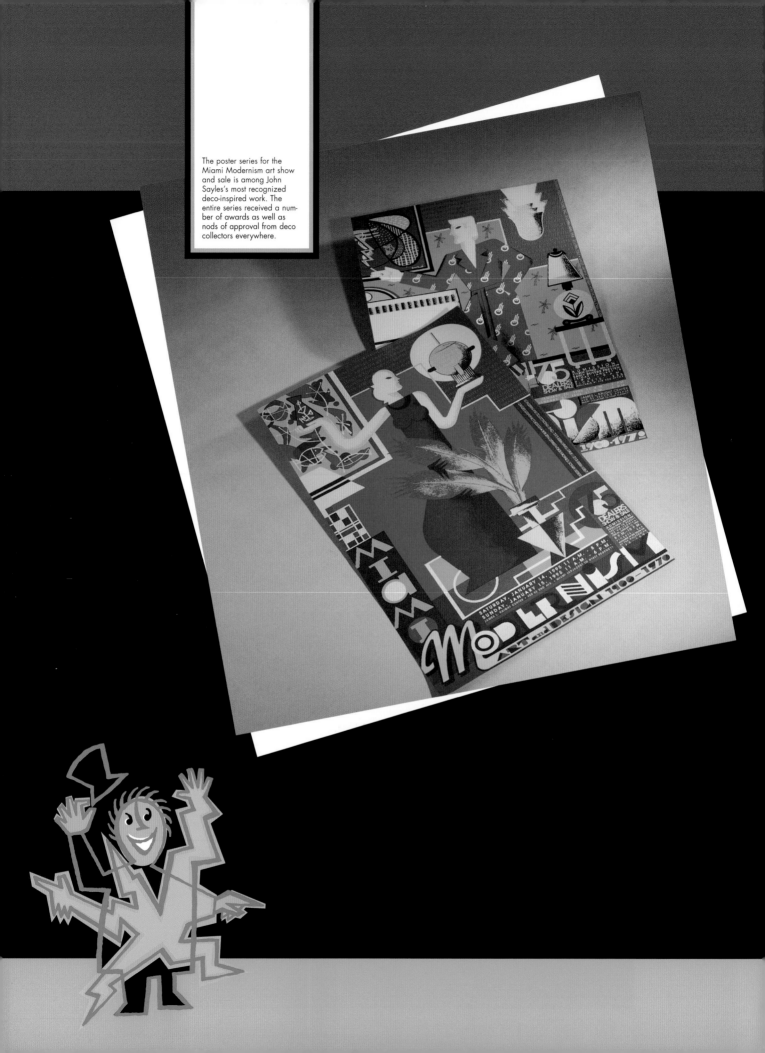

SAYLES GRAPHIC DESIGN

a
passion
for
all
things

●

design
fuels
promotion
ideas

Graphic designer John Sayles has long been inspired by industrial design legends of the 1930s and1940s—Raymond Loewy, Donald Deskey, Russel Wright, Norman Bel Geddes. The streamlined look of mid-century design has influenced much of Sayles's own style as well as what has become a massive collection of vintage furnishings, home accessories and art. Sayles is now arguably as well known for his eclectic collection of art deco artifacts as he is for his design work.

"I'm fortunate that I have a smart business partner who was able to pick up on the idea of the collection and promote it as an angle to get some great publicity," Sayles admits. "It's kind of snowballed, and it's been really gratifying to hear from so many others who appreciate this style and era of design."

Sayles outlines the ways he and his staff cross-promoted his artistic abilities and his array of deco collectibles. "The first thing that brought the two together was a poster I did for the Miami Modernism art show and sale," says Sayles. "I'd bought several items over the years from the show's organizer, and we got to talking….Once he found out I was a designer, he asked me to create the collateral for the following year's show." That was in 1994. Sayles has designed the promotional materials for the event each year since. "We entered that first poster in competitions and it won awards and got published. Each time it was printed, the caption always said something about how my personal interest in the deco era influenced the style of the poster."

Sayles's business partner subsequently wrote a media release about the posters' burgeoning popularity among art deco collectors—and how it reflected Sayles's home environment—and a new era of the firm's publicity had begun.

The release about the posters was sent to local, national and trade publications as well as select broadcast media. A regional magazine called *The Iowan* was the first to come calling, followed by *Collectibles* magazine, *Personal FX: The Collectibles Show* on cable's FX channel, and the Discovery Channel's *Home Matters* program. Through each television taping, Sayles's assistant was snapping pictures: "We mailed photos and information to every appropriate publication on our mailing list, to freelance writers who write about graphic design, to our local paper, even to my college alumni newsletter," he recalls. Sayles says that whenever possible he ties his design firm into interviews about his home and collections. "Especially in my case, since my work and personal passions are so closely related, it's a lost opportunity for me not to mention it," Sayles explains.

This angle of "the business of design" was one used by Discovery's *Home Matters* program, which featured several of Sayles's projects in the segment. "The Discovery program was a big deal to us," says Sayles. "It was taped well in advance of its air date, so we had an opportunity to really promote it." Sayles did just that. Using leftover room on a print run for a client, he ended up with two thousand direct mail pieces at a fairly low cost. "We also decided to host a party to 'premiere' the show to our closest clients and good friends—we took advan-

52

TIPS FROM JOHN SAYLES

• Have passion for everything you do: You've got to really want to be a great designer, and put your heart and soul into it.

• Continuity is good, but too much of it can work against you. Keep your campaigns fresh.

• Know your audience. What need should your promotion satisfy?

• A good client relationship is what keeps them from searching elsewhere. Work as hard to keep your clients as you do to get them.

• Consider "personalizing" your promotions with personal tidbits or a photo to let your audience get to know you.

• Treat your self-promotion projects as though they were jobs for clients. This means a schedule, a budget, a deadline. It's the only way to stay on task and not spend too much!

• Evaluate your promotions after the fact. If something is not working, examine why and address it.

• Keep your database clean. Misspelled names, wrong titles—these things can ruin even the most creative self-promotional effort.

tage of the mailer to include a handwritten invitation to those individuals."

Since the founding of Sayles Graphic Design in 1985, its staff has worked diligently to promote the firm's design work in as many ways as possible, and with the more recent addition of the deco angle there's no shortage of topics to promote. Sayles says, "Our firm does a wide variety of work, from restaurant interiors to direct mail to logos, so it's not very hard to find things to talk about."

Sayles's promotional efforts don't stop with media releases. Clients and prospects do whatever it takes to stay on the firm's mailing list due to the unusual and whimsical promotions Sayles Graphic Design sends on a regular basis. "We've mailed everything from clocks to coffee beans to compasses for our clients, and eventually just figured it

made sense to do it for ourselves, too." Sayles says self-promotional mailers don't have to be really expensive, or really elaborate, just clever and clear. "We sent everyone on our mailing list a pencil once, with the message that we could help them 'sharpen their image.' It mailed in a regular #10 envelope and included a business reply card. People loved it, and they still ask for pencils."

In the end, Sayles says it's a giant circle of promotion. "We write releases about projects, they get in the press, people find out about us, they come to us for a project, the project wins an award, we write a release about the award-winning project, it gets into the press. . .and on and on. There's no way to estimate what promotion has meant for our firm. I can honestly say that no matter how good your design work is, if someone doesn't know about you, they can't hire you."

Sayles Graphic Design uses special events as promotional opportunities for the firm. When John Sayles's 1939 deco home was featured on The Discovery Channel's *Home Matters* program, he announced a celebration with a fold-out invitation showcasing the interior of the home. Another mailing invited clients to a reception with the tagline "Birds of a feather flock together."

Sayles Graphic Design announced their presence on the Internet with a campaign of direct mail postcards, a small brochure and a T-shirt with the message "Click for pics."

Photos taken at Sayles's home during the taping of television shows are included with press releases about the designer's home and his work.

A frequent speaker to professional groups around the country, Sayles often is asked to design a commemorative poster for the event. His recognizable bold style is supported by clever headlines like "Shake Things Up" and "A Sayles Pitch."

KIMBERLY BAER DESIGN

G E T N O T I C E D !

"pet" projects

Everyone knows that a successful self-promotion is one that has a unique angle, breaks through the clutter and makes a memorable impression. Kimberly Baer Design has made a practice of taking a traditional promotion and adding a twist: an unusual theme or story. Take, for example, "Dearly Beloved"—a small illustrated booklet containing friends' and clients' stories of now-departed pets and how they met their maker. Or "The Shoe Book," a wire-o bound brochure with a wry look at people's obsessions with shoes. Or mailers with real—and typically bizarre—first-person accounts from various projects. "It's fun for our designers," says firm principal Kimberly Baer. "We can work in new creative areas, letting loose on a 'pet' project and displaying our firm's creative talents. What recipients hear and remember from each of these projects are those talents and how they tell a personal story." In addition to the increased awareness in their audience of potential customers, nearly each promotion has brought the firm new business.

TIPS FROM KIMBERLY BAER

• Find a low-cost method to show your work, such as postcards; use it regularly and send to a wide mailing list.

• Set some "wish list" goals for new clients you'd like to have or new areas of design you'd like to work in, and create promotions that target your audience.

A die-cut dog bone adorns a promotion inspired by memories of favorite pets.

A Chicago screw binding holds these unique card mailings together: Unusual stories about different design projects are featured on each promo.

Kimberly Baer Design Associates culled photos of unique shoes and produced a booklet about footwear.

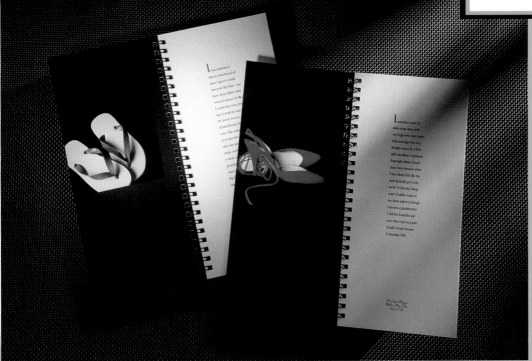

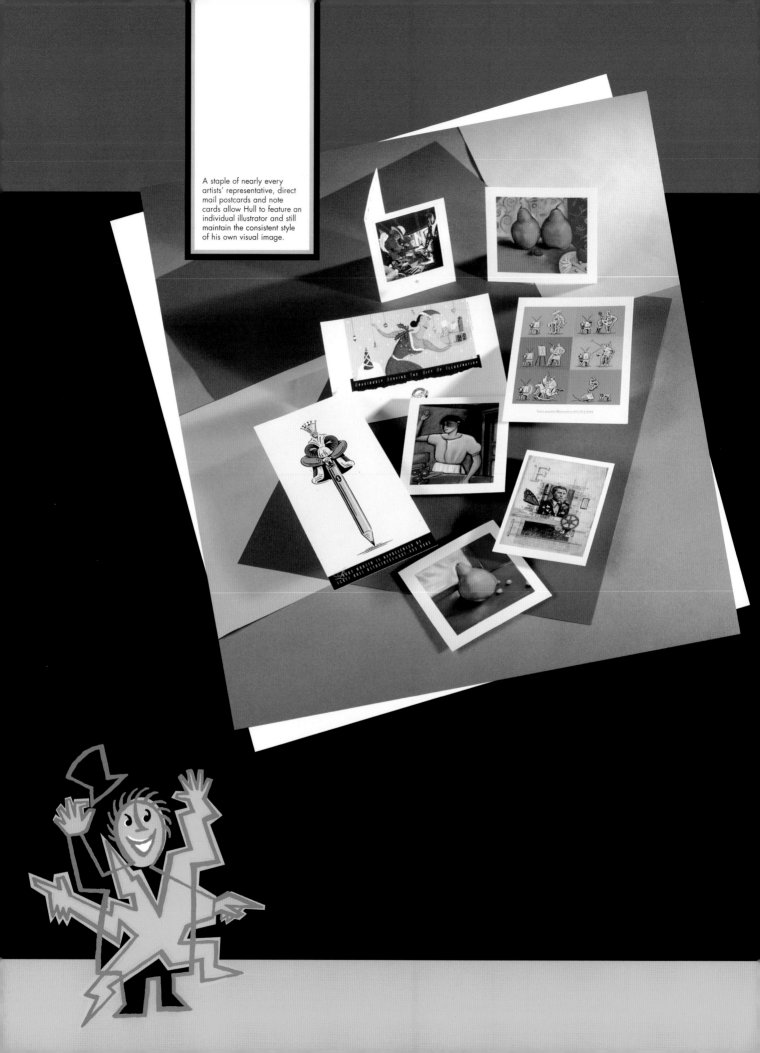

A staple of nearly every artists' representative, direct mail postcards and note cards allow Hull to feature an individual illustrator and still maintain the consistent style of his own visual image.

SCOTT HULL ASSOCIATES

rtists' representative Scott Hull has a more challenging and visually sophisticated audience than your average creative professional: He promotes his firm—and his stable of talent—to designers, art directors and art buyers. His marketing materials have a handmade, heavily illustrated feel to them—an appropriate approach for someone who represents so many different individuals and illustration styles.

From the beginning, creativity drove Hull's mission. "Our belief is that creating art is a personal thing, and we make sure that individuality comes through in our promotions." Hull and his staff make sure that each marketing effort finds a way to offer personal tidbits and an understanding of each artist. "The most valuable asset we have is our artists' creativity," Hull says, "and we use it to reinforce the benefits of our services."

When it comes to promoting his agency, Hull says, "We try to stay in a creative mindset at all times." Hull uses a multiple-step process to develop each promotion and focus on what the agency must do to stand above the rest. He first brings clients together to discover their needs. The same "think tank" approach is then used during a group meeting with all the artists Hull represents. Finally, Hull brainstorms within his own firm, resulting in a final concept that fits the overall vision for the company. Despite the lengthy process, Scott Hull Associates (SHA) churns out close to a dozen promotions each year from its Dayton, Ohio studio. His Midwestern location is the motivation for SHA's many promotions,

all of which Hull calls "absolutely necessary to remain on the cutting edge of the illustration industry."

Before he began promoting his illustrators, Hull started with his own firm's image: After fifteen years in business, it was time for an overhaul. To more clearly identify his studio's purpose, the new design incorporates a single logo—the name Hull—with a series of characters composed of individual arms, legs and heads from various illustrators' work. The resulting figures are a subtle reminder of the individual artists and styles Hull represents, and the somewhat disorderly collection of characters form a strong, consistent visual image. Hull also developed a slogan, "Movin' illustration across the nation," which is included on each piece in the stationery program.

In a brochure called the "Hull Notebook," the agency combines the deliberately random cut-and-paste style of the letterhead program with Hull's commitment to promote each artist and their individual style. The forty-eight-page booklet includes spreads for twenty-one of the agency's illustrators, which feature several work samples and amusing "secrets of the artists." Another piece is similar in concept but far different in format: A group of oversized luggage tags are tied together with a length of string. Each tag contains an illustration by an artist, a partial client list and contact information. In both promotions, the creativity of the artists' work takes center stage, revealing a new and individual style with each page, but maintaining the cohesive look of the Hull identity.

In recent years Hull has added conventional advertising to his marketing mix,

GET NOTICED!

finding the creativity at the heart ● of promotions for over twenty artists

TIPS FROM SCOTT HULL

• Make your promotion say "Wow!" with creativity and impact. Be sure your pieces convey energy, enthusiasm, excitement, initiative, drive and ambition

• Continue the learning process as an artist: It will be reflected in your work

• Be energetic yourself in your approach to promotion *and* your business's development: It's the quickest way to succeed

• You're a brand; remember that a brand has a strong logo and ad campaign.

• Cultivate healthy relationships with your clients.

• Become an expert by developing a strong knowledge of the markets in which you work. Then distinguish your unique abilities from others selling the same thing.

• Don't be afraid of small, quick projects: They often lead to larger and more substantial jobs.

which for illustrators generally included only sourcebook ads and direct mail postcards. However, recognizing that more promotion couldn't hurt, he uses his artists' talents and creativity to design materials that showcase recent projects. Calendars, decks of playing cards and other promotions are developed to keep the agency's name in front of clients for extended periods of time. Hull also created Hullabaloo, a newsletter that keeps his artists and clients aware of trends and issues in the visual communication industry. His firm produces how-to brochures for illustrators on topics like annual reports. Hull even takes advantage of speaking engagements to compile surveys, producing and distributing booklets about various subjects after the event. Each effort includes the artwork of one or many Hull-represented artists, calling on their creativity to make the promotions memorable and effective.

Hull will also develop mailers for individual artists: Oversize greeting cards, brochures and other items are designed with the artist's style and personality in mind. He will also work with paper mills and merchants in an effort to cross-promote a particular product, a method he recommends for any type of creative professional. "Teaming up with a paper company keeps costs down and provides you with distribution opportunities (by the merchant's representatives) that you wouldn't normally have access to," Hull remarks.

Because styles come and go, Hull's promotions continue to evolve and change. "We always try to work smarter, and actively and enthusiastically accept the responsibility for improving creativity."

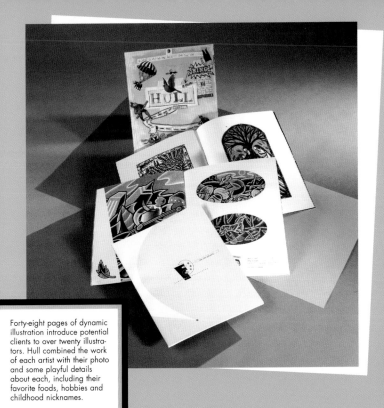

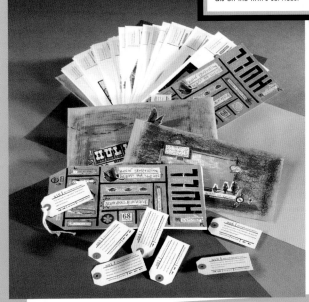

A length of nylon twine binds a stack of oversized luggage tags together, each demonstrating the individual illustration style of an artist represented by Scott Hull & Associates. A smaller tag is tied to the cord, printed with one of a series of quotes and testimonials on the firm's services.

Forty-eight pages of dynamic illustration introduce potential clients to over twenty illustrators. Hull combined the work of each artist with their photo and some playful details about each, including their favorite foods, hobbies and childhood nicknames.

A group of abstract characters draws attention to Scott Hull's corporate identity system. A variety of special effects adds impact, including two-side printing and die cuts.

What better way to keep your name in front of clients and potential clients for an entire year? Scott Hull & Associates' calendars are filled with illustrations that are suitable for framing, unless the recipient would rather request the series of accompanying posters that Hull provides. A return reply card included in the calendar facilitates the request.

To promote an individual illustrator, Hull uses a giant greeting card with a die-cut window. A lithograph is tipped inside, allowing a portion of the image to peek through the die cut.

MCCULLOUGH CREATIVE GROUP

separate yourself from the "me toos"

Three pieces from Iowa-based McCullough Creative Group showcase the firm's creative thinking. A moving announcement fits in a #10 envelope and invites the recipient to "pop in" to the firm's new location; affixed to the front is a square of packaging bubbles. To invite clients and friends to get a taste of the new studio at an open house, another card is mailed, this time with an hors d'oeuvres pick glued to the front. As guests left the party, a conveniently packaged T-shirt—called the Creativitee—is a reminder that McCullough Creative Group is a perfect fit. Studio principal Jack McCullough says, "We wanted to separate ourselves from the 'me toos,' and all our promotions give us the unique ability to do something that's creative, that's outside the box. Great promotions always start with a great idea!" Other ideas that McCullough has turned into successful self-promotions are McCullough Chocolates, swirled with the firm's M logo, and Creative Juices, bottled water filled with a "magic potion" for success.

TIPS FROM JACK McCULLOUGH

• Make your promotion clever—get your prospects thinking that you approach projects differently than the norm.

• Show off your creativity! People will realize that you can also produce effective work for them.

McCullough adhered sections of bubble wrap and party toothpicks to moving announcements and party invitations.

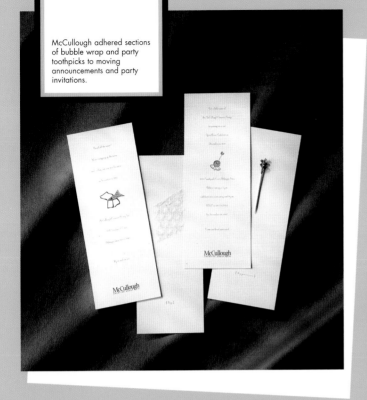

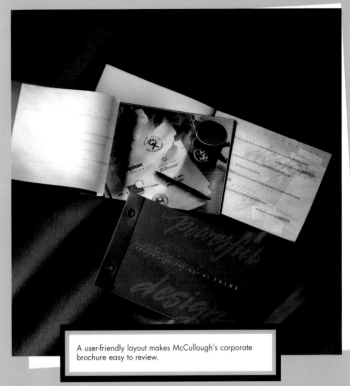

A user-friendly layout makes McCullough's corporate brochure easy to review.

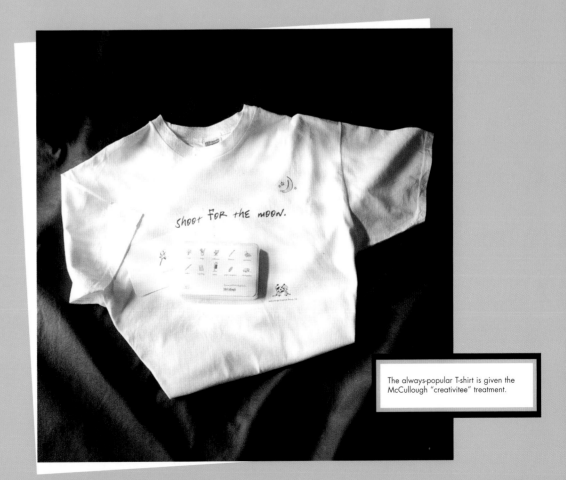

The always-popular T-shirt is given the McCullough "creativitee" treatment.

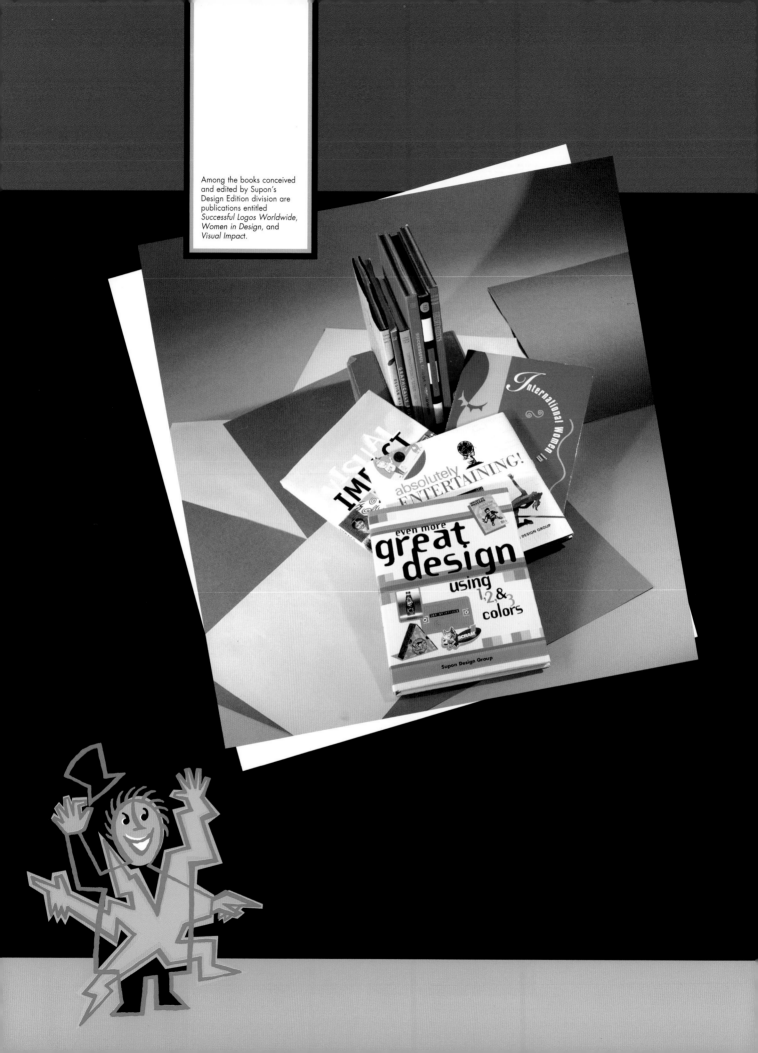

Among the books conceived and edited by Supon's Design Edition division are publications entitled *Successful Logos Worldwide, Women in Design,* and *Visual Impact.*

SUPON DESIGN GROUP

GET NOTICED!

writing the book on ● successful self-promotion

Like many successful design studios, Supon Design Group is often featured in competition annuals and design books. But have you ever noticed that many of the books themselves also have Supon's name on the spine?

Supon Design Editions, the successful book publication division of Supon Design Group, was developed in 1990 as an outlet for developing the firm's own promotions. Studio principal Supon Phornirunlit explains, "We'd always talked about how important it was to be complete and thorough in a self-promotion, and that can be hard to do in a brochure or mailer. The idea of producing a book was a natural for us."

One of the most successful of Supon's books is *DesignWise*, a hardbound edition that was published in 1997 and distributed in bookstores around the world. *DesignWise* provides a case study of Supon Design Group itself and more than two hundred examples of work, plus special sections highlighting work for individual clients. Supon also uses the book with current and potential clients alike, mailing them with personal notes or leaving one behind after a meeting. Phornirunlit says, "Our objective was to appeal to higher-end clients, bigger corporations, bigger projects, bigger budgets—by looking bigger ourselves and more impressive." And it worked: The firm now works on projects for IBM, the United States Postal Service, Special Olympics and Coca-Cola.

Phornirunlit attributes much of his business success to such self-promotions, also crediting them for his firm's highly visible image. "Prospects see proof of our capabilities in our books and in the implicit 'references' by big-name clients whose projects we show off."

A second book, called *Making Your Mark*, discusses identity design with significant commentary and plenty of visuals, all the while reinforcing Supon's commitment to appeal to a specific audience with each promotion. "Any marketing effort needs to be educational as opposed to just picture books," says Phornirunlit.

These books promoting the studio evolved into publications about the design industry in general, and the firm began to seek out work of other creative professionals to include. Industry-wide competitions now provide between three thousand and five thousand submissions to Supon publications each year, and the firm has edited over thirty books to date on topics including logo design, typography, entertainment graphics and more. As the number of books in progress increased, it was obvious to the staff at Supon that there needed to be a group of individuals dedicated to these publications.

"By devoting a division of our firm to Design Editions, we can organize competitions for books that will have meaning and purpose to the design industry," Phornirunlit says. "And even if we have no work featured, each one is a promotion for ourselves. We conceive the concept, manage the competition, design and market each publication. We are indeed promoting our firm's abilities to the public with each book."

TIPS FROM SUPON PHORNIRUNLIT

• Determine a specific marketing objective right away: Who do you want to appeal to? Conceive a piece that will attract that particular audience.

• The *whole* package must be high-caliber and distinctive; this includes the visuals and the writing! Concept, development and execution must work together.

• Timing is important. Promote sports-related work prior to the Olympics or publication abilities before annual report season.

• Consider every aspect of every client project a self-promotion. If you do a strong job, they'll be back and maybe they'll even tell their friends. If you do a poor job, you can be sure they'll tell their friends.

Supon also works hard to market the books that Design Editions puts out. A detailed database keeps track of all the firms who have submitted work in the past, and they are contacted about upcoming publications as well as newly released books. A Web site specific to Design Editions is linked to Supon's general site, with an entirely different graphic identity from its parent firm. Even loose comment postcards inside each book sold at the retail level provide additional names for the database as well as direction for future publications, determined in part by readers' comments.

In addition to the resources that must be dedicated to such a division, there is another down side for Supon: The audience to whom these competitions and books appeal is primarily Supon's competition—other design firms, as opposed to other clients. To offset this effect, the firm submits its work to other types of industry competitions—for instance, their clients' business sectors, or professional associations in which potential clients may be members.

Phornirunlit oversees the development of each publication himself, adding responsibility for the Design Editions division to his leadership role with the designers working for the studio's extensive client list. He also is primarily responsible for the firm's self-promotional activities: "It's important that the objectives and strategies—and budgets!—for each promotion are consistent with this firm's overall mission," he says. "We must convey our marketing message in a controlled manner to specific audiences."

It's not just within the pages of a self-published book that Supon promotes his firm. Clients and prospects have received a set of note cards featuring his two dogs Pica and Cricket, a watch in a tin container, a full color twelve-page newsletter, moving announcements, party invitations and more, all with the lively Supon look. From his very first promotional effort in 1988, a four-page brochure called "My Name Is Supon," Supon Phornirunlit has made himself—and his studio—a name in the design *and* publishing worlds.

T-shirts and gifts are a favorite way to commemorate special happenings, and Supon Design Group uses them for a variety of events. A bright orange shirt announces a Halloween party, while a retro-style shirt was given to employees during a company retreat in Orlando.

A hardbound book and a stuffed dog with a watch for a collar were among the items created to support a yearlong promotion. The theme "Making Your Mark" refers to the campaign's focus: Supon Design Group's prowess in designing corporate identity.

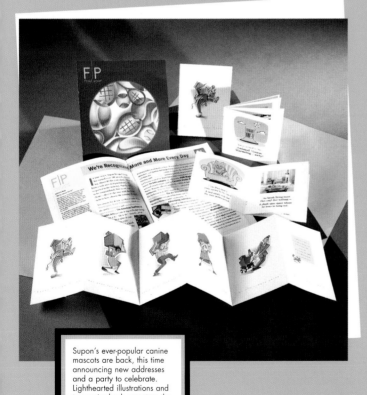

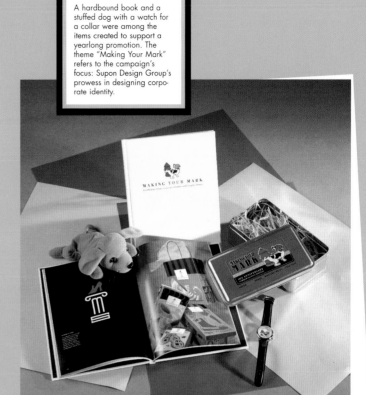

Phornirunlit's two dogs have the run of his Washington, D.C., studio, where they are pampered by staff and clients. An unusual gift doubles as a truly unique promotion: four different renderings of the pair of pooches grace a set of notecards that includes a recipe for doggie biscuits. Another card series features a group of space-inspired illustrations housed in a wooden cigar-style box.

Supon's ever-popular canine mascots are back, this time announcing new addresses and a party to celebrate. Lighthearted illustrations and tongue-in-cheek copy turn the practical nature of these mailers into a warm and friendly message. The dogs also show up from time to time in *Final Proof*, Supon's colorful newsletter mailed to clients and staff.

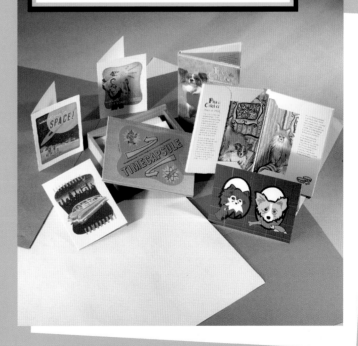

VISUAL ASYLUM

send holiday gifts!

"We have four criteria for our annual holiday gift," says Visual Asylum principal MaeLin Levine. The promotion must include a book of some sort, an object, a play on the word "asylum," and a way to mass-mail to the studio's extensive contact list. Since beginning the tradition in 1994, Visual Asylum has sent greetings that have included nutcrackers in the shape of the firm's logo accompanied by fresh nuts; cookies packaged with flip-books about making holiday "ku-kes" (cookies); and coloring books with crayons for a do-it-yourself design. Each promotion has found its way into the hands—and sometimes stomachs—of clients, with the resulting goodwill of a thoughtful gift *and* a lasting reminder of Visual Asylum, thanks to the power of promotion.

TIPS FROM MAELIN LEVINE

• If you've designed products for promotions, sell them! Extra mouse pads, T-shirts, notepads, pencils, etc., can be an additional source of revenue—and publicity!

• Be an active member of the design community: Participate in local professional associations, enter design competitions and submit work to books.

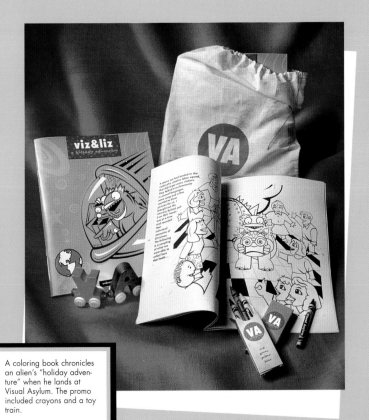

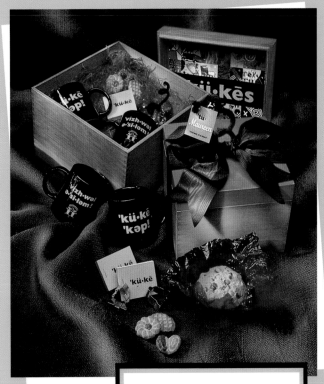

Visual Asylum's gift of cookies is a feast for the eyes as well as the stomach.

A coloring book chronicles an alien's "holiday adventure" when he lands at Visual Asylum. The promo included crayons and a toy train.

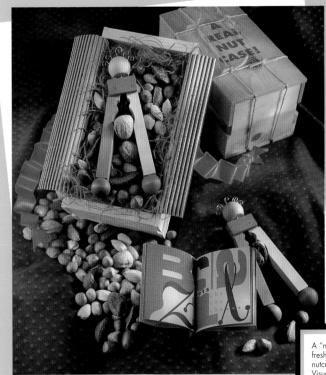

A "nutty" promo included fresh nuts and a handmade nutcracker inspired by the Visual Asylum logo.

A metal hubcap is clamped to the top of this round corrugated box that is sent to Winston•Ford clients as a holiday gift. Inside, a road map proclaims "Peace on Earth" before lifting out to reveal a booklet printed on rubber pages and a cozy orange sweatshirt. Three patches are sewn on one sleeve of the shirt: Winston, Ford and Route 66.

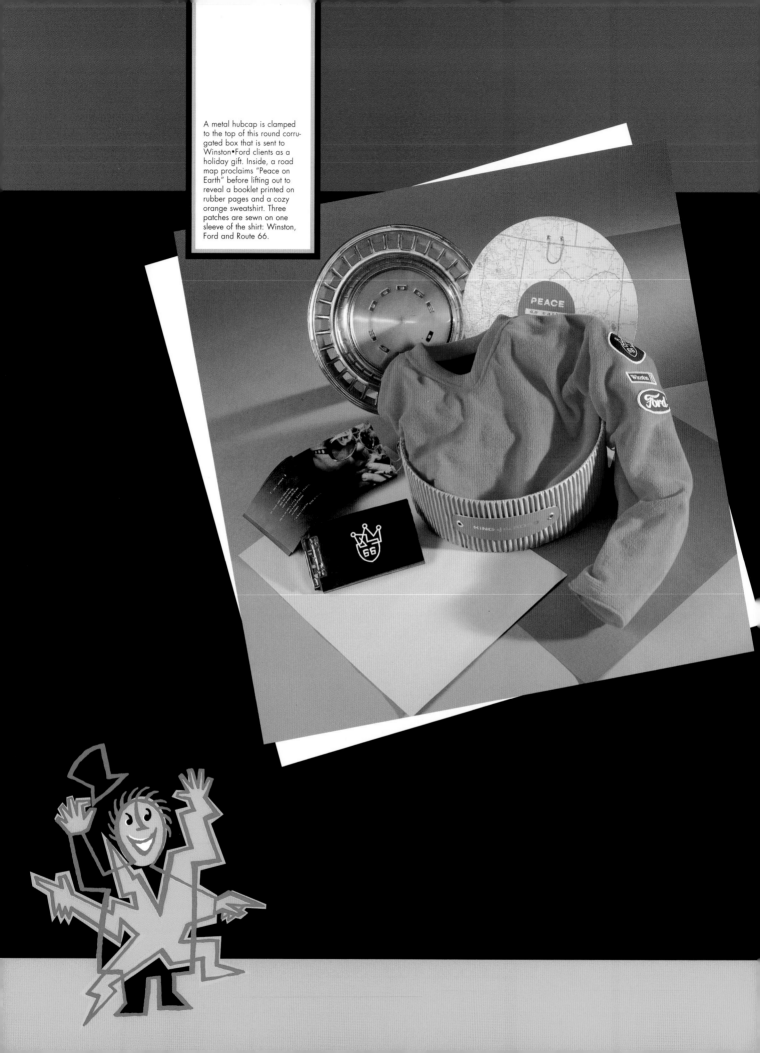

WINSTON•FORD DESIGN

Richard Hollant may not be the king of the road, but his design firm Winston•Ford is certainly a contender for king of self-promotion. The big, showy mailers developed by the firm are significantly more than meets the eye. "Our intent is to have everything we do contribute to the desired perception of who we are," says Hollant. And while that desired image may be fresh and new, the creation of this image is deliberate and strategic in nature.

Hollant and his wife Bonnie started their firm in 1988 after working several years at other firms. Like many designers, both were frustrated by the limitations of working for someone else, so they struck out on their own.

After ten successful years in business, Hollant knew his firm could do better and finally decided it was "officially" time to test the waters of self-promotion. Since Hollant considers himself "anything but a natural salesperson," Winston•Ford hired a new business director and a public relations firm, who worked together to set up an organized, systematic sales and marketing plan. The public relations firm hit the ground running, taking Winston•Ford from anonymity to the front page of the local business newspaper, the *Hartford Courant*, in an article entitled "Promotional Pitches." Two additional articles in other publications addressed several of the philosophies and ideals established in the marketing plan.

The studio has continued to review the plan's effectiveness and update it to accommodate the growth and changes at Winston•Ford. "We've found that direct mail is one of the most effective methods we can use," Hollant says. "Bonnie and I create direct mail promotions that our new business director uses: generally two pieces per year, but we don't do bulk distribution," Hollant stresses. "We identify key companies we want to work with and focus our energy on that list. Typically it's twenty-five to thirty companies per quarter."

Each promotion that Hollant's firm uses falls into one of three marketing approaches: identity, informational, or promotional/incentive. Identity promotions are the most fundamental and include the basics like stationery as well as a Web server for clients to access project updates. Informational mailings include hardbound sample books, smaller promotions including logo and promotion booklets, and media and business updates sent to clients and the press to assist in the firm's direct solicitation of work.

The third type of marketing approach, promotional and incentive, most clearly shows who Winston•Ford is and what the firm can do. Hollant's strategy behind each of these attention-getting mailers is simple: Speak with a voice that is truly Winston•Ford's own. Each direct mail promotion is designed to inspire and challenge the recipient, causing them to think about design and its effects. Two successful mailings were presented as holiday gifts and received with enthusiasm and understanding. "King of the Road," a round corrugated box lined with road maps and topped with an actual hubcap, contains a steel-clamped rubber book and a bright orange sweat-

GET NOTICED!

Big-time direct mail projects make a big impact

70

TIPS FROM RICHARD HOLLANT

• Know something about the recipient you're sending stuff to.

• When sending material or presenting in person, use project samples that are relevant to the client's industry whenever possible.

• A promotion doesn't have to cost a lot: It has to mean a lot.

• No one promotion can be all things: Structure your message so that the impact of *all* pieces shows a well-rounded, approachable person or company.

shirt. Hollant says the piece brings the recipient on a unique journey through the use of familiar icons. More importantly, it also convinces clients—and potential clients—that Winston•Ford thinks creatively *and* strategically, two equally critical aspects of a successful marketing program. Another holiday promotion, called "Use Your Noodle," had clients' brains and taste buds working overtime. Hollant's staff made fresh pesto with ingredients from his garden and packaged it with multi-colored rotini pasta. Winston•Ford plans to continue the tradition with a new concept each year. While clients can appreciate the thoughtfulness of such a gift, they also recognize the significance of the message that Winston•Ford "uses their noodle," not just their creative talent.

"King of the Road" and "Use Your Noodle" are two of an inventory of promotional materials that Winston•Ford's new business director uses selectively throughout the year as needed. "Self-promotion puts a face with the name of our little company," says Hollant. "To us, promoting our design company is no different than promoting any brand name or corporation." Winston•Ford's approach to communication on their clients' behalf is the same as communicating their own message: Infuse the environment with a pointed message that can be understood both intellectually and emotionally.

Once Winston•Ford's promotional message is received by a prospect, Hollant feels strongly that his follow-up must have the same impact as the first impression. He emphasizes the importance of connecting with prospects on an emotional, personal level. "Our promotions get us the opportunity to sit down for an hour

or two with people who understand the value of innovative marketing strategies. That dialogue is what gets us the work; the promo just provides the opportunity to talk." Hollant estimates that as a result of the twenty-five to thirty "King of the Road" promotions he sent, the firm was called in to bid on roughly ten different projects.

New business hasn't been the only benefit of Winston•Ford's self-promotional efforts. In early 1999, the firm was approached by another design studio in nearby New Haven, resulting in what Hollant calls a "morphing" of the two companies—a merger of sorts. The new entity is called Listen, and Hollant says the combination of each firms' strengths has brought new philosophies to light and more opportunities to develop "cool, hip stuff." He says that it's also been practical: Overhead is lower and there are staff members with diverse skills to draw upon. Listen is as committed to self-promotion as Winston•Ford was. Hollant concludes, "Self-promotion is the best way to show a potential client—or remind an existing client—what we do best."

Hardbound books are personalized for each client and customized to display samples of Winston•Ford's work. Another promotion features wire-o binding, which is ideal for proposals and presentations.

Winston•Ford uses several unique methods to thank prospects and clients. After a meeting, a silver corrugated envelope is sent with a personal note, printed on the back of a time card displaying the date and time of the meeting. A second mailer is a set of thank you "coupons" which can be redeemed for "nifty gizmos" bearing the Winston•Ford insignia.

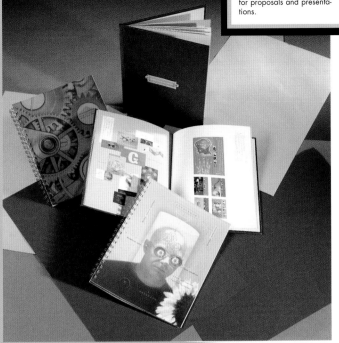

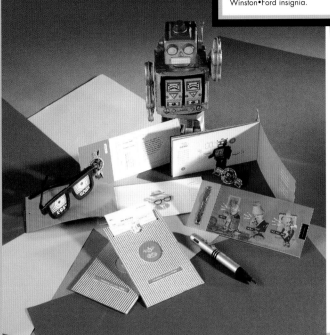

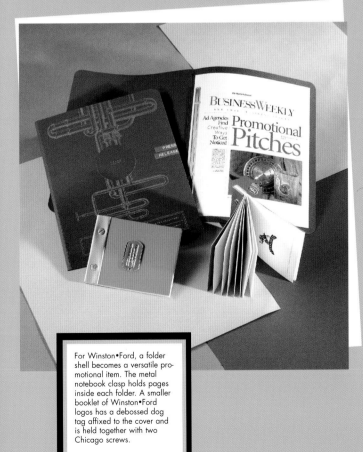

The earthy, minimalist design of Winston•Ford's letterhead program effectively uses natural colors and materials. Stock kraft and chipboard envelopes are imprinted for a budget conscious but attractive approach.

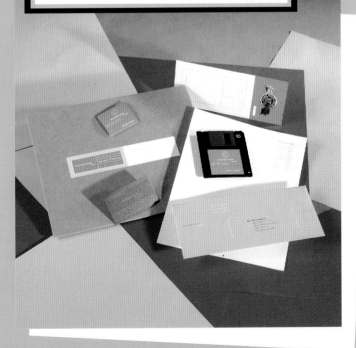

For Winston•Ford, a folder shell becomes a versatile promotional item. The metal notebook clasp holds pages inside each folder. A smaller booklet of Winston•Ford logos has a debossed dog tag affixed to the cover and is held together with two Chicago screws.

You know that as a creative professional your own self-promotion should be dynamic. You strive for the right balance of drama and credibility, seeking the perfect "theme" or creative spin. You look at what your colleagues —your competitors—have done, but you need inspiration and a creative spark.

The following gallery of self-promotion ideas is truly a global compilation. Scores of design firms share hundreds of ideas to help jump-start your own next marketing effort. Learn how designers, illustrators, photographers and other creative professionals in the following nations promote themselves and their firms.

- **Portugal**
- **Italy**
- **Spain**
- **Canada**
- **United States**
- **Slovenia**
- **Netherlands**
- **Hong Kong**
- **Germany**
- **France**
- **New Zealand**
- **United Kingdom**

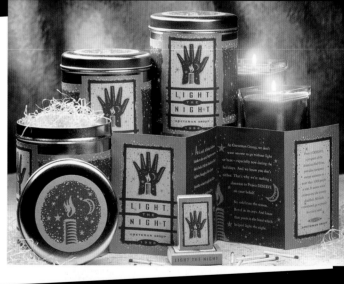

SECTION

3

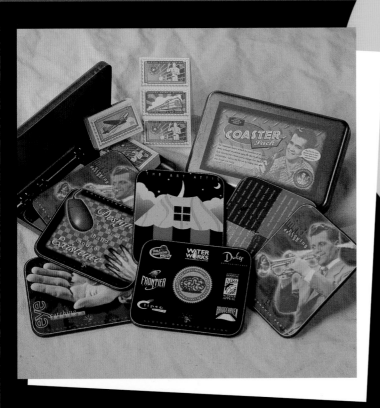

GALLERY

A Spanish designer developed a 274-page book to promote his firm. The limited edition promotion has a suede cover stamped with the title; inside pages are printed in four colors with matte varnish. Careful attention was given to details like the sewn binding and painted page edges.

DESIGN FIRM:
Osoxile S.L.
(Spain)

A "recipe box" of heavy chipboard cards showcases over thirty design projects. Photos of brochures, logos, corporate identity programs, Web sites and more are laminated to the front of the cards, while the back side features a description of the project. Two small brochures are included, providing a philosophical overview and a case study.

DESIGN FIRM:
Factor Design
(Germany)

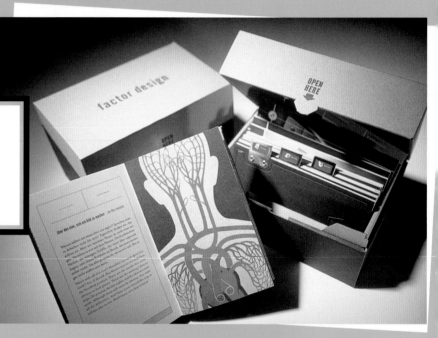

To describe her thought process, this design student used layers of different papers to separate different elements of graphics including layout, type definition and color, taking a three-dimensional view of a two-dimensional design. The brochure is presented in a vellum wrap.

DESIGNER:
Marisa Wisber
(USA)

The capabilities brochure for this design firm doubles as an invitation to visit its Web site. Custom graphics and four-color images of sample projects are used to provide a preview of the work created by the firm.

DESIGN FIRM:
Bradbury Design
(Canada)

This series for Seth Affoumado Photography evolved from the concept of a photographer extracting past mental images to influence present work. The title of the promotion, "Rewind," represents this process; duotone photographs contribute to the surreal look.

DESIGN FIRM:
Fuel
(USA)

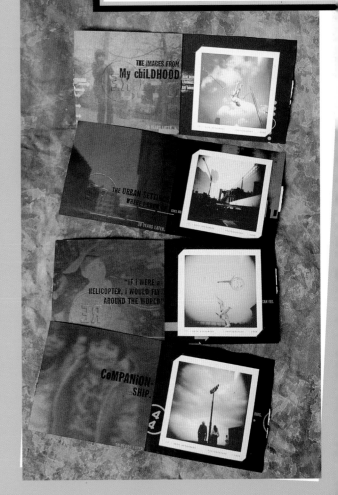

Designer Doug Bakker uses several special effects—from embossing and wire-o binding to stochastic screening—in this brochure to promote the services of his Iowa-based firm.

DESIGN FIRM:
Bakker Design
(USA)

A capabilities brochure for a finishing company makes use of all the services it offers including UV coating, film laminating, foil stamping, engraving, thermography, die cutting, embossing and debossing. Copy includes tips on the successful execution of special effects.

DESIGN FIRM:
D.E. Baugh Co., Inc.
(USA)

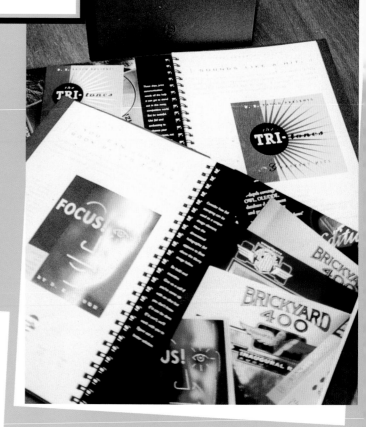

A type designer developed a small booklet of text with a wraparound tab to hold it closed. His theme, "Type should speak for itself," allows the words to have their own voice. An appealing graphic is the logo formed from his initials, D and O.

DESIGNER:
David Ortega
(USA)

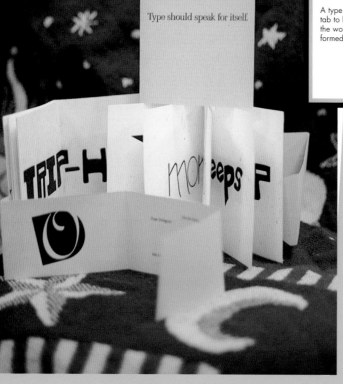

The pages of several small brochures are inspired by stamps. The perforated sheets are printed on one side and, when trimmed and moistened, can be adhered to other surfaces. Similar graphics are also found on follow-up cards, each containing additional information on the design firm and its work.

DESIGN FIRM:
HeadQuarter
(Germany)

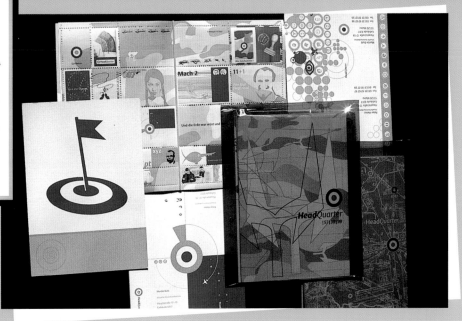

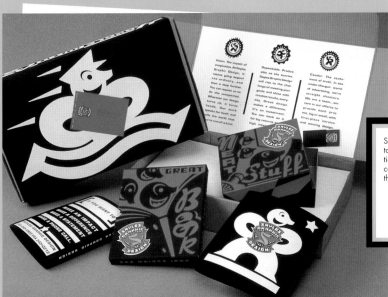

Sayles Graphic Design uses a "special delivery kit" to introduce itself to potential clients. The firm can quickly and easily tailor the presentation with photos, articles, slides, samples and a video. Promotional components fit into a large box, which is printed on the inside lid with the firm's philosophy.

DESIGN FIRM:
Sayles Graphic Design
(USA)

A tabloid newspaper was the inspiration for this quirky poster for Cahan & Associates.

DESIGN FIRM:
Cahan & Associates
(USA)

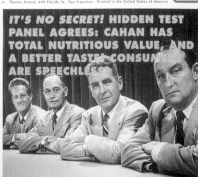

Created to show Prairie Sun Recording as a state-of-the-art facility, the images in the promotion underscore the tranquil location of the studio.

DESIGN FIRM:
Fuel
(USA)

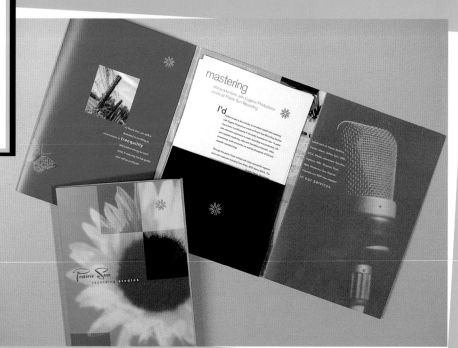

An illustrator's range of skills is displayed on different-sized sheets inside a small brochure. Flocked wallpaper makes an unexpected cover, and an adhesive name tag serves as a bookplate for the title of Eric Hanson's piece.

REPRESENTATIVE:
Joanie Bernstein
(USA)

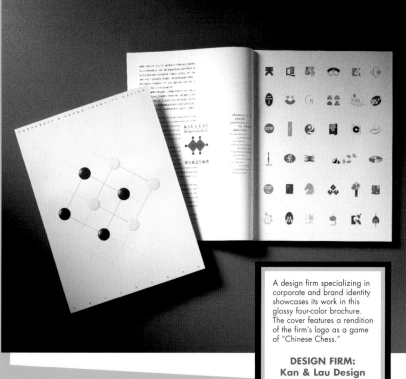

A design firm specializing in corporate and brand identity showcases its work in this glossy four-color brochure. The cover features a rendition of the firm's logo as a game of "Chinese Chess."

DESIGN FIRM:
Kan & Lau Design
Consultants
(Hong Kong)

To demonstrate the firm's varied disciplines, this uniquely shaped brochure contains the same information on both sides: Only the design is different. "It's an example of the way we design to suit the objectives of particular assignments," says the firm's director of business development. Makeready press sheets were converted into envelopes, and test mailings ensured that the unusual shape would mail well.

**DESIGN FIRM:
Alan Brooks Design
Inc.
(USA)**

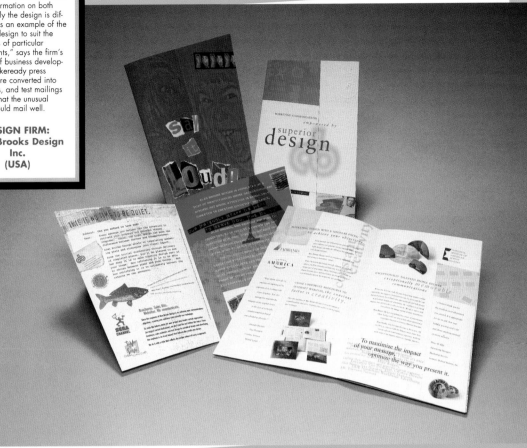

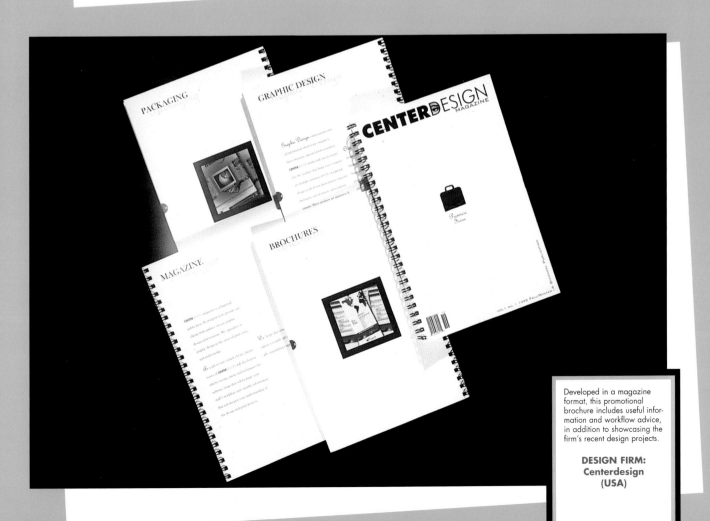

Developed in a magazine format, this promotional brochure includes useful information and workflow advice, in addition to showcasing the firm's recent design projects.

**DESIGN FIRM:
Centerdesign
(USA)**

Folds, labels and a dramatic A die cut emphasize Artcraft Printing's accomplishments and capabilities while it celebrates five decades of operation. A fifty-year timeline was included to tell the printer's story.

DESIGN FIRM:
Belyea Design Alliance
(USA)

This promotion for David Carter Design Associates is a collection of quotes by well-known peace leaders as well as regular people. The intent of the greeting is to explore the many ways that the simple concept of "peace" is expressed and passed from person to person, nation to nation.

PHOTOGRAPHER:
Terry Vine Photography
(USA)

Tiny but impactful, this brochure to promote a photographer measures a mere 3 ¹/₂" x 4 ¹/₂". Perfect binding makes the piece seem more substantial, and the photographer's signature on the front cover of each makes it keepable.

PHOTOGRAPHER:
Ed Cunicelli
Photography
(USA)

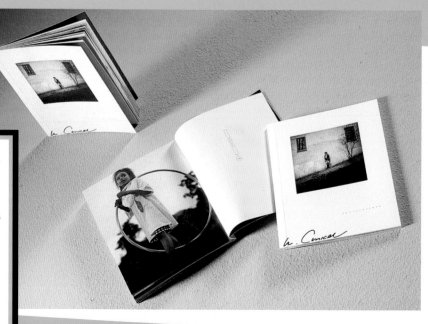

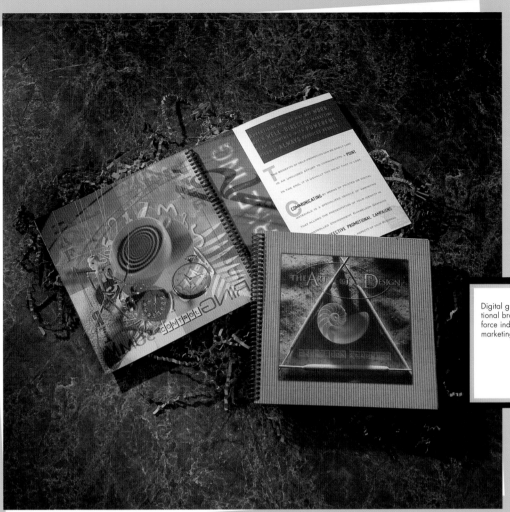

Digital graphics are at their best in Chameleon's promotional brochure. Dramatic collages on every page reinforce individual messages about the firm's approach to marketing, creativity, technology and other design issues.

DESIGN FIRM:
Chameleon Group, Inc.
(USA)

An accordion-fold brochure highlighted with die cuts solved the problem of how to promote Hunter Films+Photography. Two brothers had joined their individual photography and filmmaking businesses, but they still wanted to maintain their separate identities. Each side of the brochure focused on one sibling's area of expertise.

DESIGN FIRM:
Weaver Design
(USA)

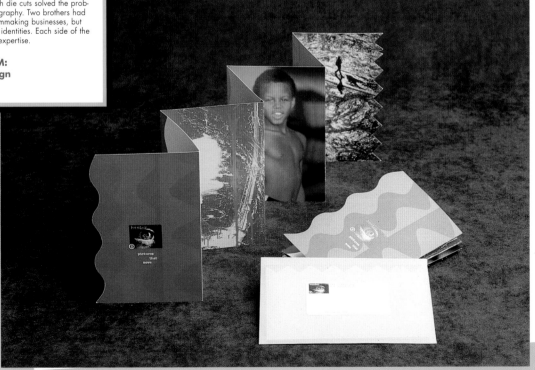

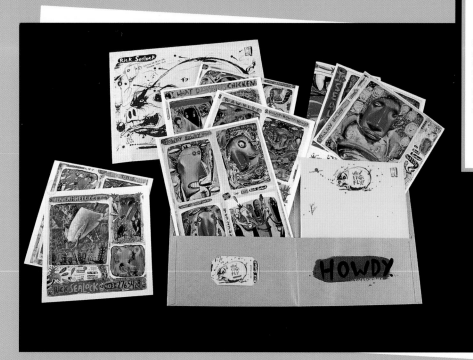

Samples of an artist's editorial and advertising projects are presented in a colorful self-promotional kit entitled "Howdy." Items include postcards, tear sheets, labels and a story book illustrated by the artist.

ILLUSTRATOR:
Rick Sealock
(Canada)

To assert herself as a problem-solving graphic artist, a college student developed a brochure filled with ideas, steps and methods used during the design process. A business reply card is included in the promotional mailing.

DESIGNER:
Stacy Shapiro
(USA)

To promote a unique service to evaluate and analyze the strengths, weaknesses, opportunities and threats (SWOT) in their clients' market positions, a design firm developed a small brochure with a big impact.

DESIGN FIRM:
Thoma Thoma Creative
(USA)

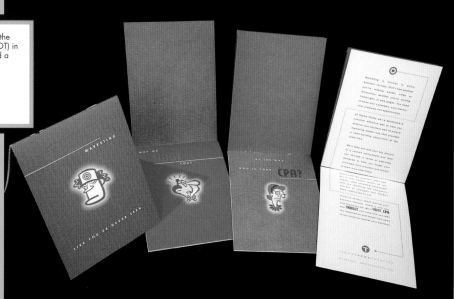

Type and images interacting
in different situations are
found throughout a design
student's promotional
brochure. Metallic pages add
to what the designer calls
"visual dualism."

DESIGNER:
Michelle Prescott
(USA)

A collection of materials for a freelance designer uses kitchy 1950s
graphics and type, bright colors and a clever theme. A die-cut
brochure includes a resume and work samples; several postcards are
sent before and after the main promotion.

DESIGNER:
Pam Meierding
(USA)

Spiral-bound, hand-assembled books are part of an efficient
self-promotion program. The comprehensive overviews are
enhanced by the use of tactile materials including cardboard,
corrugated and metal elements. The pieces are mailed as
needed, and the positive response from clients justifies the
added effort.

DESIGN FIRM:
Greteman Group
(USA)

A Dallas advertising agency offers clients and area residents a free restaurant guide that outlines the agency's recommendations for dining in the local area. "Fedele's Guide to Civilized Dining" expands Flowers & Fedele's new business marketing program by helping current and prospective clients enjoy doing business with the firm.

AGENCY:
Flowers & Fedele,
Inc.
(USA)

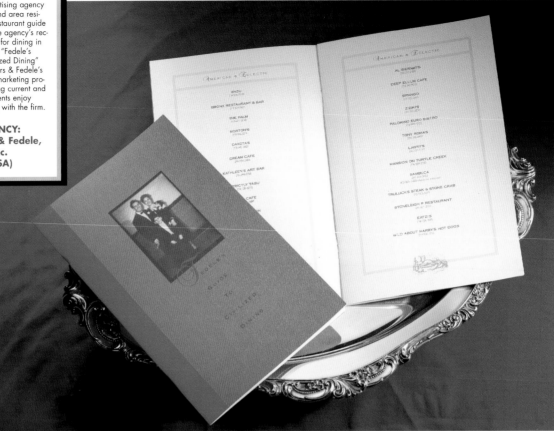

This one-of-a-kind promotion was sent to a potential client in the coffee industry. The headline asks, "What's the Measure of Good Design?" The subhead inside replies, "Just Under a Cup." When the cup is lifted, the design firm's logo is revealed.

DESIGN FIRM:
L3 Creative
(USA)

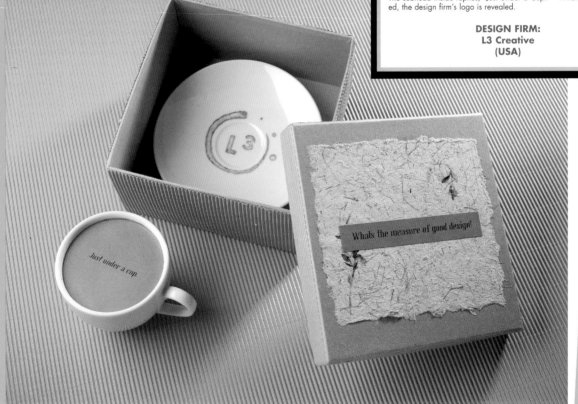

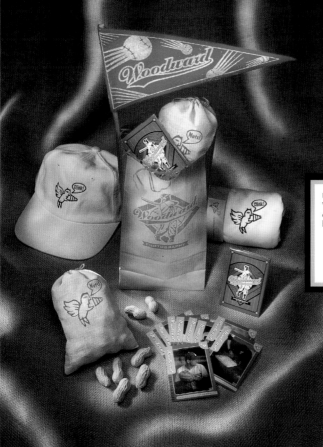

Using outtakes from his work with a baseball client, photographer Bob Woodward developed a clever and memorable promotion that included a series of baseball cards, a pennant, a cap and T-shirt, and a bag of peanuts. Woodward's logo is printed on each piece.

DESIGN FIRM:
Visual Asylum
(USA)

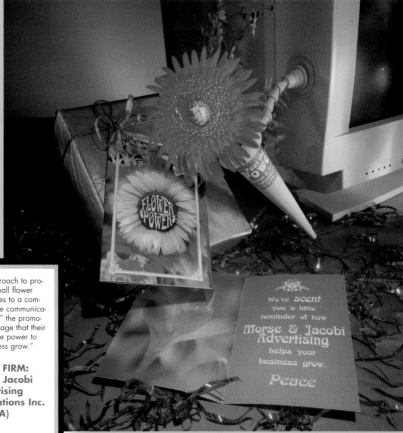

An unusual approach to promotion is this small flower vase that attaches to a computer screen. The communications firm "scent" the promotion with a message that their services had "the power to help your business grow."

DESIGN FIRM:
Morse & Jacobi
Advertising
Communications Inc.
(USA)

86

A design firm incorporates cultural diversity into promotions. The first two letters of each word in the name of this studio are combined to form a third word, which is then translated into Japanese. The resulting symbol is then printed with the firm's name on small pads of paper and distributed to friends and clients. Translations to other languages resulted in different graphics for other promotions.

DESIGN FIRM:
Likovni Studio Ltd.
(Croatia)

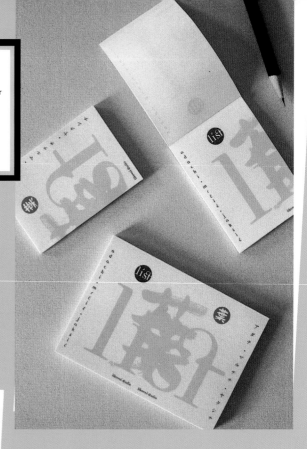

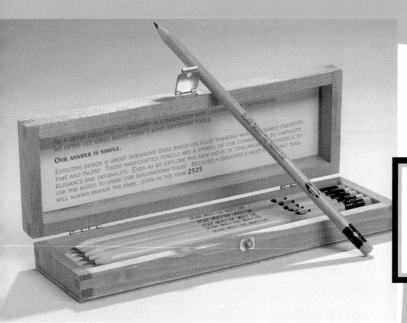

A hinged wooden box is an elegant presentation for a dozen pencils, presented by design 25/25. The firm's philosophy on the importance and simplicity of designers' tools is printed on a label inside the box lid.

DESIGN FIRM:
Design 25/25
(USA)

A stock paint can is transformed into a colorful tin with the help of bright graphics printed on the label. A warning indicates that the homemade cookies inside the can are "hazardous waist material."

DESIGN FIRM:
DeLuca Frigoletto Advertising, Inc.
(USA)

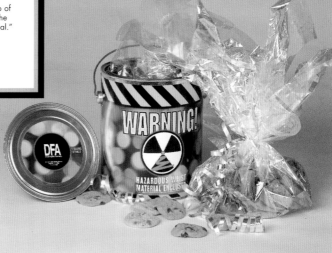

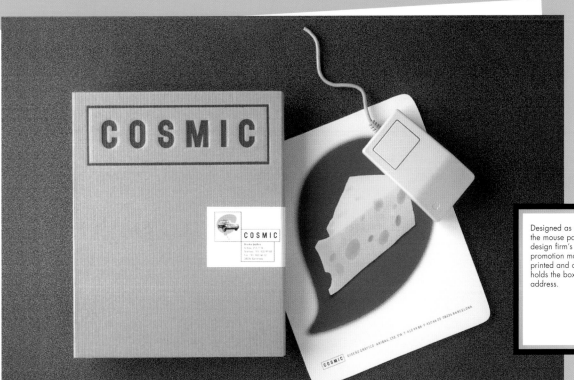

Designed as a gift for clients who use computers, the mouse pad includes a cheese visual and the design firm's address and phone number. The promotion mails in a corrugated wrap that is printed and debossed; a wraparound sticker holds the box closed and includes the return address.

DESIGN FIRM:
Cosmic
(Spain)

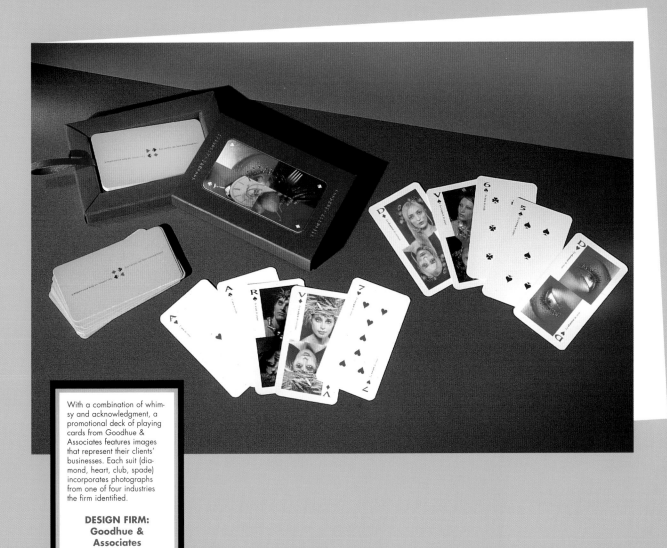

With a combination of whimsy and acknowledgment, a promotional deck of playing cards from Goodhue & Associates features images that represent their clients' businesses. Each suit (diamond, heart, club, spade) incorporates photographs from one of four industries the firm identified.

DESIGN FIRM:
Goodhue &
Associates
(Canada)

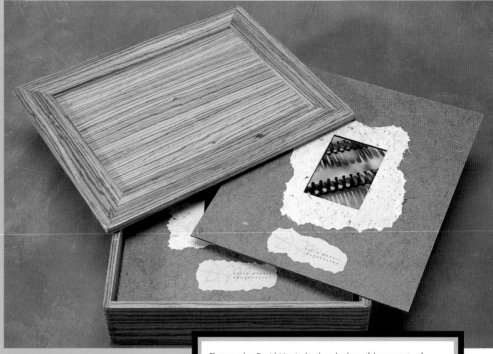

Photographer David Morris developed a beautiful presentation for samples of his work: Images are mounted and "framed" on textured handmade papers, then transported and displayed in a unique wooden box.

PHOTOGRAPHER:
David Morris Photography
(USA)

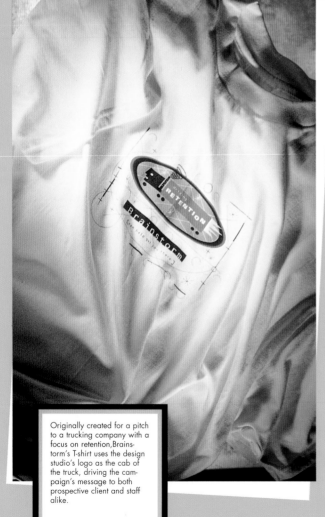

A gift for clients, friends, and vendors includes a custom-made mug and a pound of "screamin' java jolt" coffee beans.

DESIGN FIRM:
DeLuca Frigoletto Advertising, Inc.
(USA)

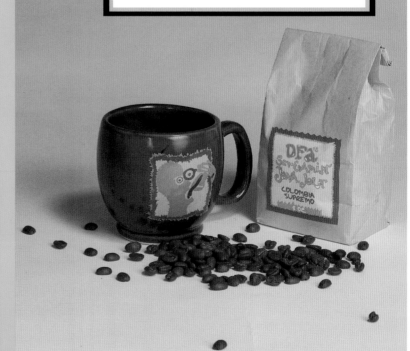

Originally created for a pitch to a trucking company with a focus on retention, Brainstorm's T-shirt uses the design studio's logo as the cab of the truck, driving the campaign's message to both prospective client and staff alike.

DESIGN FIRM:
Brainstorm Inc.
(USA)

To reflect their high-impact, high-energy design, this firm stuffed fun T-shirts into colorful cans, which have proven to have a life of their own beyond the shirt transport.

DESIGN FIRM:
Studio D
(USA)

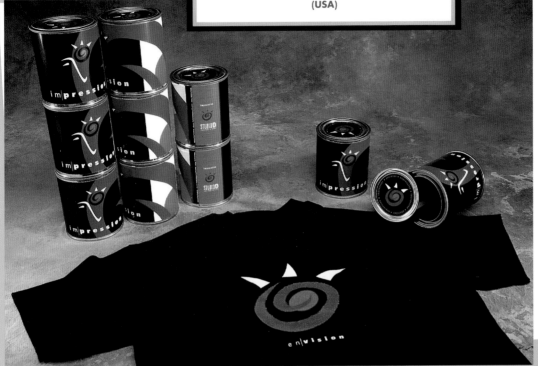

Graphics of motorcycle parts—complete with descriptions—are letter-press-printed on a stadium hot dog bag, transforming it into an envelope for illustrator Dan Picasso's promotion. Inside is a label featuring a stylized motorcycle!

REPRESENTATIVE:
Joanie Bernstein
(USA)

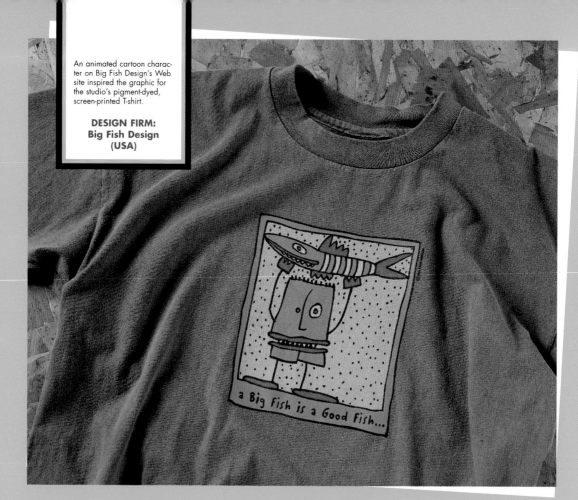

An animated cartoon character on Big Fish Design's Web site inspired the graphic for the studio's pigment-dyed, screen-printed T-shirt.

**DESIGN FIRM:
Big Fish Design
(USA)**

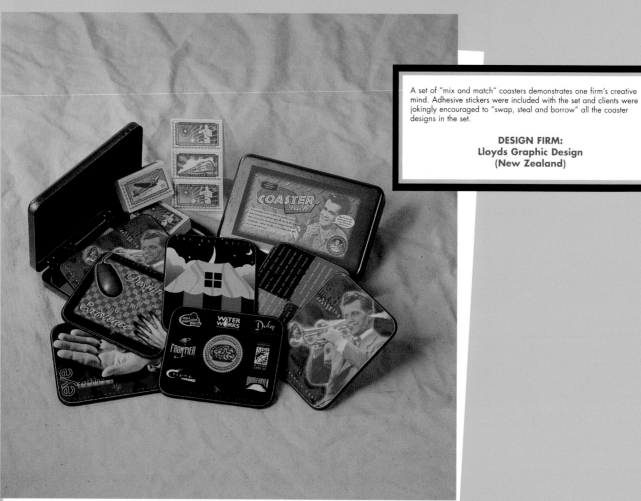

A set of "mix and match" coasters demonstrates one firm's creative mind. Adhesive stickers were included with the set and clients were jokingly encouraged to "swap, steal and borrow" all the coaster designs in the set.

**DESIGN FIRM:
Lloyds Graphic Design
(New Zealand)**

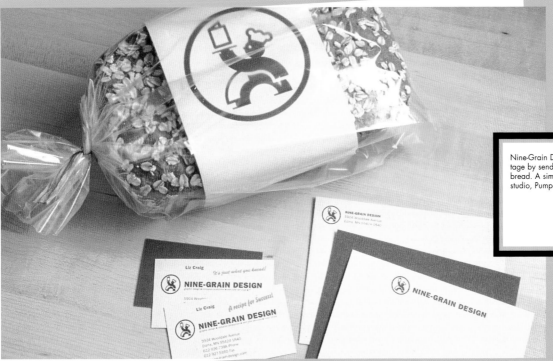

Nine-Grain Design uses their firm's name to its best advantage by sending prospects a loaf of homemade nine-grain bread. A similar program is used for an affiliated letterpress studio, Pumpernickel Press.

DESIGN FIRM:
Nine-Grain Design
(USA)

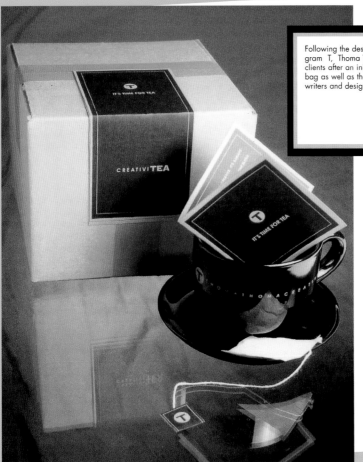

Following the design of a new corporate identity featuring their monogram T, Thoma Thoma Creative developed a gift for prospective clients after an initial meeting. "CreativiTEA" includes a mug and tea bag as well as the firm's "fine blend of the richest minds and talented writers and designers, steeped with great service."

DESIGN FIRM:
Thoma Thoma Creative
(USA)

A hospital's in-house creative department utilized a retro stock image as a visual for it's unique corporate identity. The firm's name "Say Ah!" conjures up medical images as well as giving the impression of "ahhh, nice work."

DESIGN FIRM:
"Say Ah!" Creative
(USA)

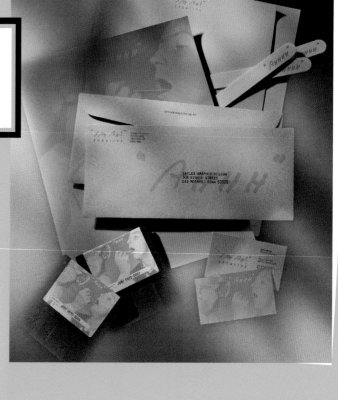

Seeking variety in how the firm is represented, this designer developed a series of business cards, each in a different style.

DESIGN FIRM:
Fons M. Hickmann
(Germany)

This unusual pyramid was an interactive promotion. The reader put the piece together and learned historical trivia about the letter E—as in Embry, the printer's name. The type and color pattern echo the print shop's recently redesigned identity.

DESIGN FIRM:
Kimberly Baer Design Associates
(USA)

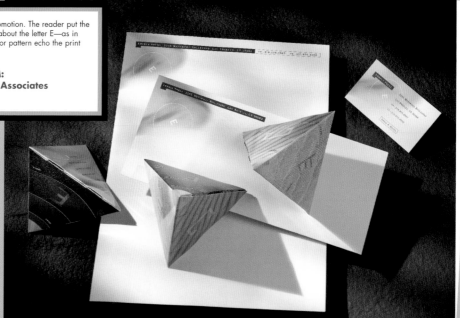

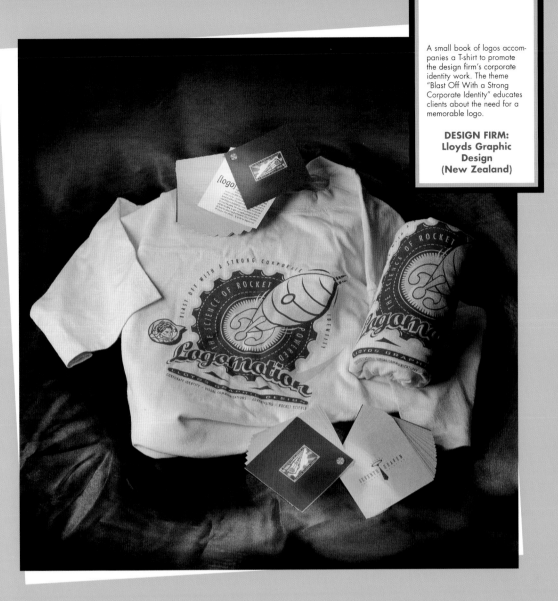

A small book of logos accompanies a T-shirt to promote the design firm's corporate identity work. The theme "Blast Off With a Strong Corporate Identity" educates clients about the need for a memorable logo.

**DESIGN FIRM:
Lloyds Graphic
Design
(New Zealand)**

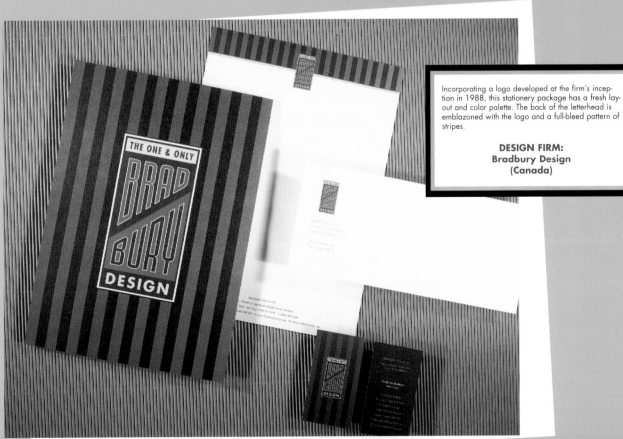

Incorporating a logo developed at the firm's inception in 1988, this stationery package has a fresh layout and color palette. The back of the letterhead is emblazoned with the logo and a full-bleed pattern of stripes.

**DESIGN FIRM:
Bradbury Design
(Canada)**

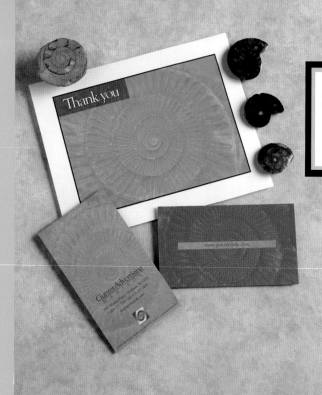

Using a graphic of an ammonite as a part of its visual identity, this advertising agency occasionally sends actual fossil ammonites to clients and prospects to help make a memorable impression.

AGENCY:
Gunter Advertising
(USA)

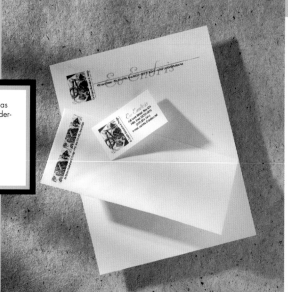

A corporate identity that promotes illustration capabilities as well as design, this two-color letterhead program features an original rendering of artists' tools.

DESIGN FIRM:
Ev Endris Illustration & Design
(USA)

A unique promotion entitled "Pin Me Up" included these memorable "business cards"—ordinary clothespins screen printed with the firm name and contact information.

DESIGN FIRM:
A+B In Exile
(Slovenia)

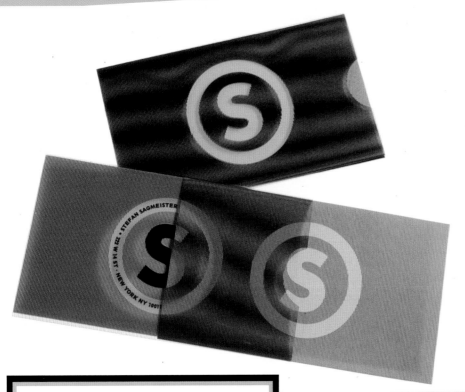

Three layers of material form this unusual business card. A white chipboard card is printed with the monogram *S* and the address in a circle of type, then thumb-notched. A layer of plastic is printed with the monogram and type circle knocked out of very fine lines, then the plastic wraps around the card to form a pocket. A second chipboard card is printed with the same fine lines and knock out as the plastic, then slid into the pocket. The designer admits the cards are "a pain in the ass" to produce, but the resulting holographic image is so popular the cards have been reprinted four times.

DESIGN FIRM:
Sagmeister Inc.
(USA)

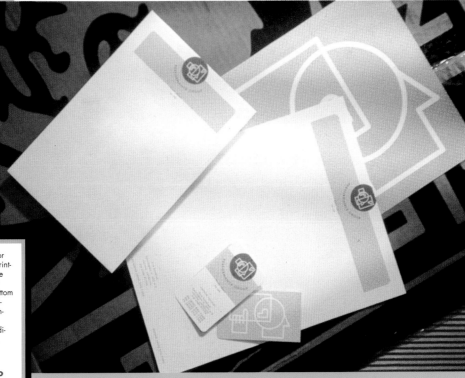

The letterhead program for Performance Group—a printer who also offers creative services—features die-cut rounded edges on the bottom of the letterhead and business cards. A custom converted 6" x 9" envelope takes the place of the traditional #10 size envelope.

DESIGN FIRM:
Labbé Design Co
(USA)

96

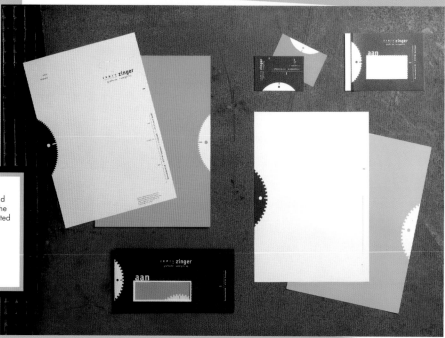

Admittedly using fluorescent colors "to be noticed," this designer floodcoated the back of his firm's letterhead and the inside of its converted envelopes with neon colors. The front side of each piece of the identity system being printed in only black makes it all the more dramatic.

DESIGN FIRM:
Erwin Zinger Graphic Design
(Netherlands)

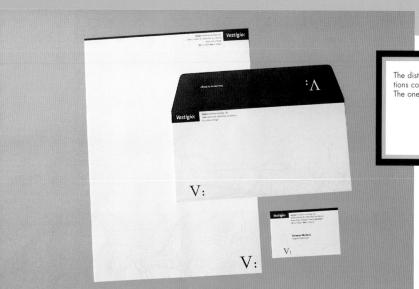

The distinctive use of the company's initial, V, and subtle line illustrations convey the elegance the firm desired for its stationery program. The one-color program is also cost effective.

DESIGN FIRM:
Vestígio, Lda.
Portugal)

Printed in small batches of five hundred, this designer's plastic business cards were produced in a variety of fluorescent color combinations.

DESIGN FIRM:
Nodal Communications
(USA)

Continental-Anchor, an
engraving company, devel-
oped this promotion to pro-
mote holiday card orders.
Special effects include
embossing on a vellum stock
and matching envelope, as
well as engraving.

**DESIGN FIRM:
Williams and House
(USA)**

Stationery and business cards for a French firm use images from
nature, including flowers, fruit and leaves. Each associate has a vari-
ety of cards for distribution.

**DESIGN FIRM:
Metzler & Associates
(France)**

Using two colors of ink for its identity program, L3 Creative added
intrigue with strategically placed die cuts—three holes of different
sizes—on the various components. The business-size envelope opens
from the side.

**DESIGN FIRM:
L3 Creative
(USA)**

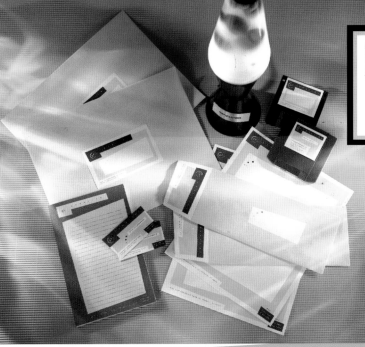

In addition to names and titles, business cards for Likovni Studio are customized with a caricature. Each playful sketch is memorable and personal.

**DESIGN FIRM:
Likovni Studio Ltd.
(Croatia)**

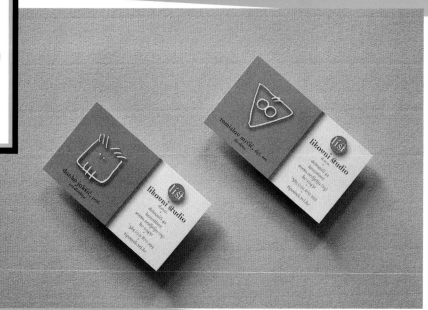

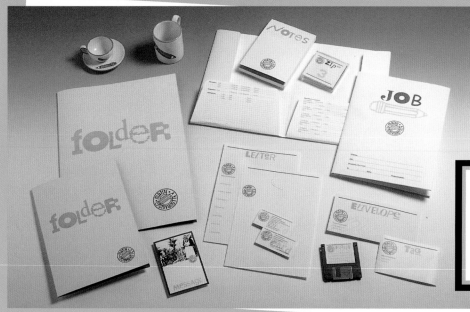

Each item in Matite Giovanotte's corporate identity program is printed with the firm's graphic pencil logo, while text in a variety of fonts and sizes displays their name. From envelopes to folders, from disk labels to notepads, each item is identified in a consistent and understated style.

**DESIGN FIRM:
Matite Giovanotte
(Italy)**

Letterhead for photographer Kimball Hall appears conservative at first glance, but a closer look reveals several creative details including the embossed phrase "Take a picture it lasts longer," as well as quotes from various poets.

**DESIGN FIRM:
Labbé Design Co
(USA)**

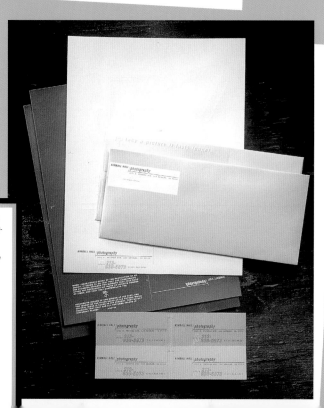

Photographer Bob Wood-
ward uses letterpress printing
for his identity system, which
includes traditional stationery
and odd-sized note cards.
The logo is found on each
piece: a whimsical bird using
a camera and chirping,
"Click."

DESIGN FIRM:
Visual Asylum
(USA)

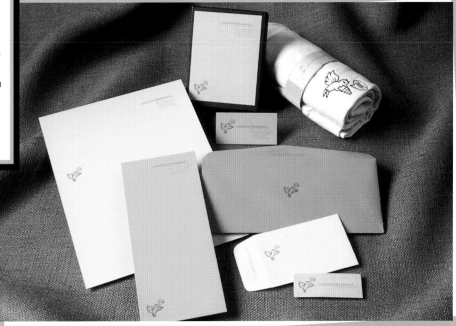

Reminiscent of a copyright symbol, the logo for Karacters Design
Group is a simple graphic *k* in a circle. Staff members' business cards
feature wide-angle photos of themselves—each revealing a bit of their
own "character" in the image.

DESIGN FIRM:
Karacters Design Group
(Canada)

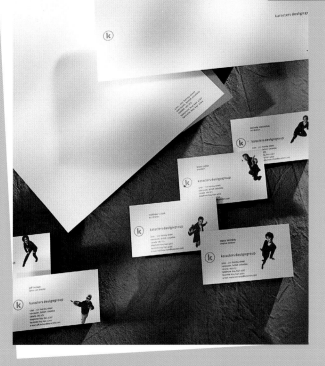

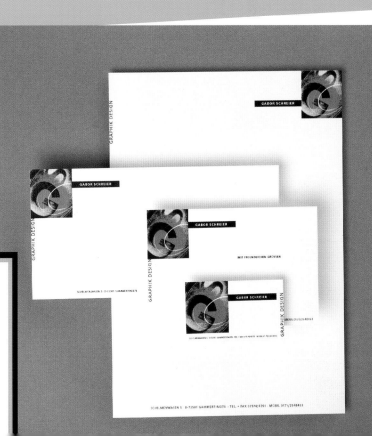

The designer's initials *G* and
S are a prominent part of his
corporate identity. The letters
were designed to symbolize
creativity and individuality,
then incorporated into a lay-
out where the colorful image
is the focus.

DESIGN FIRM:
Schreier Graphik
Design
(Germany)

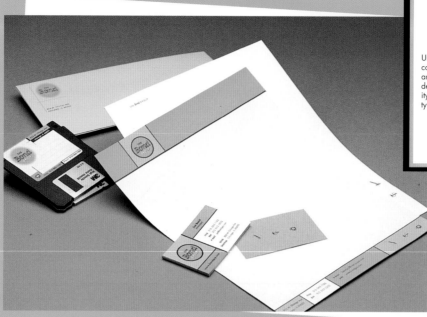

Using an unconventional color palette of chartreuse and gray, this Midwestern design firm achieves continuity within its corporate identity package.

**DESIGN FIRM:
The Bond Group
(USA)**

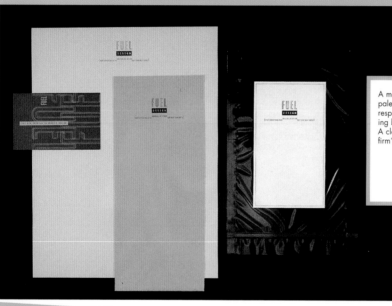

A metallic envelope is an unexpected contrast to the earthy color palette of Fuel Design's stationery program. Used primarily in response to requests for information, the silvery finish on the self-sealing bag is slightly translucent, allowing a glimpse of the items inside. A clever tag line ("The new premium in graphic design") plays off the firm's name.

**DESIGN FIRM:
Fuel Design Group, Inc.
(USA)**

Armed with a minimal production budget and the desire to evoke a sense of craftsmanship, Brand A Design created its business-papers system almost entirely of Crack'N Peel stickers. A stock manila envelope was customized with a seal, label and corner stamp.

**DESIGN FIRM:
Brand A Design
(USA)**

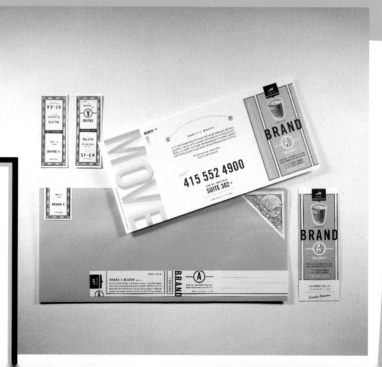

Printed in four-color process, this stationery package portrays the balance between design and the written word: The illustration of a multicolored ball balanced on the pointed nose of a three-dimensional figure is the artist's interpretation of effective communication.

DESIGN FIRM:
Balance Design, Inc.
(USA)

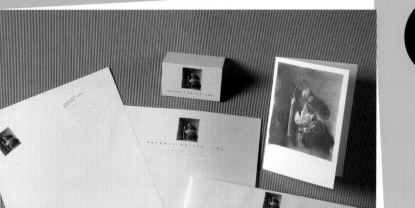

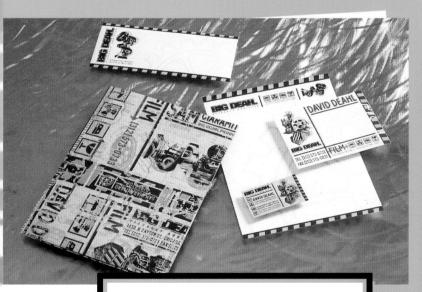

Designers achieved a strong shelf impact for Big Deahl's demo reel. The jacket is printed with symbolic icons, familiar equipment visuals and a powerful color scheme.

DESIGN FIRM:
Mires Design
(USA)

The bold, graphic look of corporate identity materials for video production company Big Deahl has a post-industrial factory feel, reminiscent of the 1930s and 40s.

DESIGN FIRM:
Mires Design
(USA)

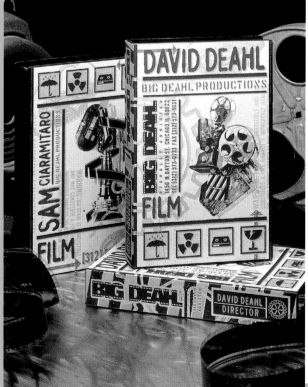

RESUMES & PORTFOLIOS

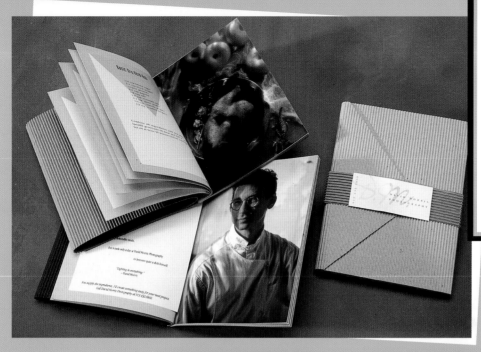

Corrugated wraps and bands protect a series of portfolios for a photographer. Each of the three volumes features a different type of work: food, people and a mixture of images with a description on the opposite page. The booklets are used as leave-behinds.

PHOTOGRAPHER:
David Morris
Photography
(USA)

Rubber covers and smooth white pages convey the diverse services of an image consultancy. Dramatic photography, simple layouts and engaging case studies make a notable impression.

DESIGN FIRM:
Wallace/Church
(USA)

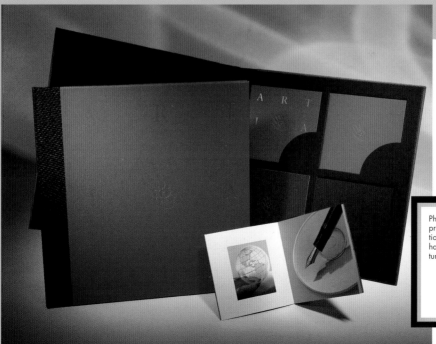

Photographer Jim Coon was challenged with finding a way to promote the diversity of his work in a unified fashion. His solution: four separate mini-portfolios-beautifully presented in a hardbound book titled "Artifacts." Each handmade book features an introduction printed on vellum.

PHOTOGRAPHER:
Jim Coon
(USA)

Chinese take-out was the inspiration for this student's promotion: a fortune cookie packaged in a to-go carton filled with uncooked white rice. The cookie's message? "In two weeks a talented graphic designer will be calling you."

DESIGNER:
Danielle Weller
(USA)

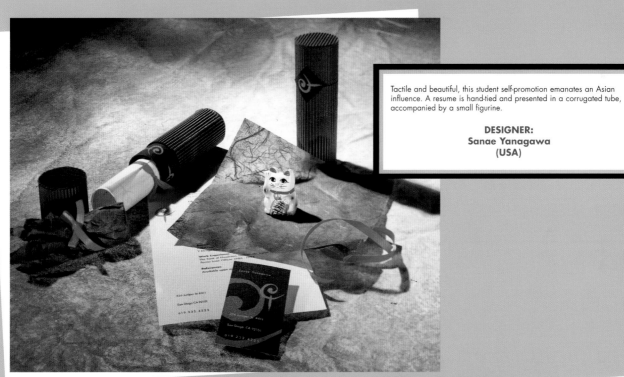

Tactile and beautiful, this student self-promotion emanates an Asian influence. A resume is hand-tied and presented in a corrugated tube, accompanied by a small figurine.

DESIGNER:
Sanae Yanagawa
(USA)

A novice graphic and environmental designer sought to position himself as someone who could design everything from "print to space." The promotion arrives in a corrugated box with sides that fall open when the lid is lifted. Inside the "room" is a dynamic combination of visual images and a 3-D art table and chair.

DESIGNER:
David Bradley
(USA)

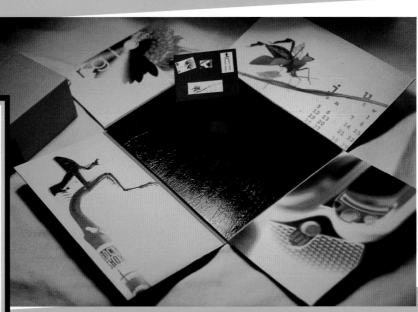

104

Two flexible steel sheets held together with Velcro are embossed, debossed and conformed to house a diverse, 160-page portfolio. The book's metallic cover protects the firm's showcase of typography, new technology, natural materials and printing techniques including holograms, die cuts, folds and unusual paper textures and weights.

DESIGN FIRM:
Attik Design Ltd.
(United Kingdom)

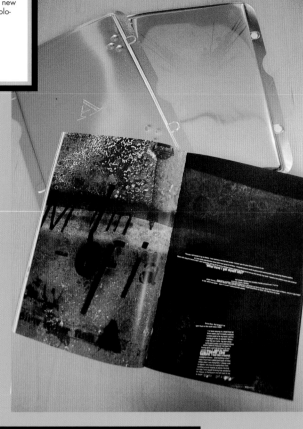

This embossed wrap contains this comprehensive portfolio for a Portuguese designer. Individual sheets feature project details and photographs of works including brochures, books, calendars and catalogs. The designer's biography is included.

DESIGNER:
João Machado
(Portugal)

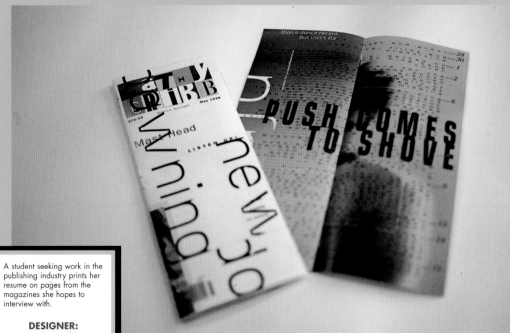

A student seeking work in the publishing industry prints her resume on pages from the magazines she hopes to interview with.

DESIGNER:
Cathy Cribb
(USA)

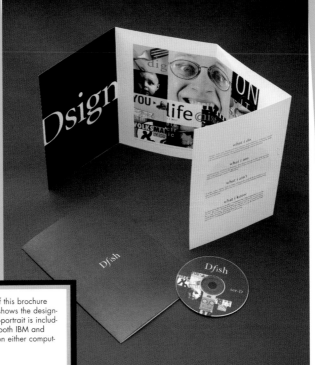

A compact disc portfolio is affixed to the last panel of this brochure that doubles as a resume. A block-style photo layout shows the designer's work for a variety of clients, and a humorous self-portrait is included. Fifty pieces were printed digitally, and the CD is both IBM and Macintosh compatible so the work can be reviewed on either computer platform.

DESIGNER:
Daniel Fish Design
(USA)

A graceful die-cut, embossed monogram and clean layout come together to make an elegant portfolio for photographer Scott Montgomery. Designed for versatility, the photos are tipped into individual sheets, allowing the presentation to be tailored for specific needs.

DESIGN FIRM:
Hubbell Design Works
(USA)

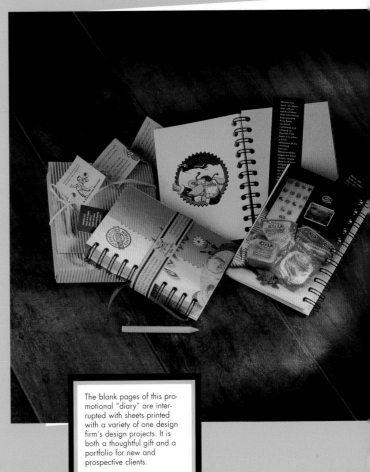

The blank pages of this promotional "diary" are interrupted with sheets printed with a variety of one design firm's design projects. It is both a thoughtful gift and a portfolio for new and prospective clients.

DESIGN FIRM:
Lloyds Graphic
Design
(New Zealand)

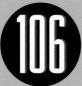

A student's self-promotion reflects her Italian heritage through clever packaging that includes a bag of pasta. The resume inside features a "nutritional chart" of computer and language skills.

DESIGNER:
Tiziana d'Agostino
(USA)

A student got his foot in the door—literally—with a weighty promotion. A plaster-cast foot is presented in a box with a brochure announcing, "Now that I've got my foot in the door, take a look at the rest of me."

DESIGNER:
Jerry Corcoran
(USA)

A tiny, playful booklet asks, "What do I want to be when I grow up?" The designer answers the question with a charming look at various professions through a child's eye before changing to an elegant, "grown-up" typographic treatment to announce her design talents.

DESIGNER:
Kimberly Van Schoyck
(USA)

Positioning himself as an "intellectual thinker," this student sent prospective employers a rubber brain and an invitation to view his "thought-provoking design."

DESIGNER:
Paul Drohan
(USA)

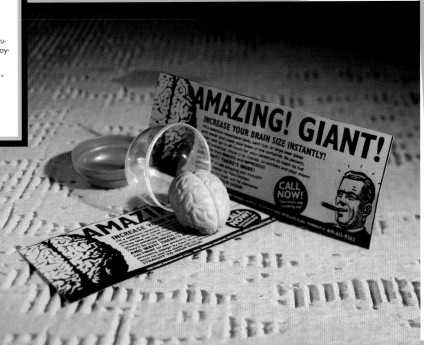

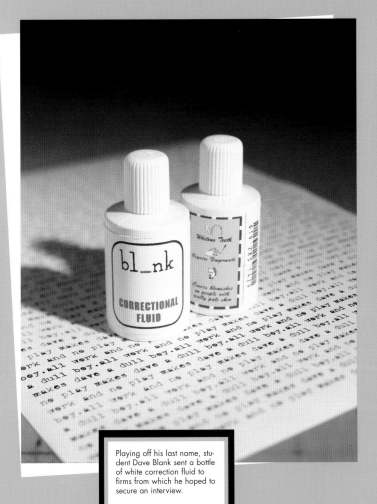

Playing off his last name, student Dave Blank sent a bottle of white correction fluid to firms from which he hoped to secure an interview.

DESIGNER:
Dave Blank
(USA)

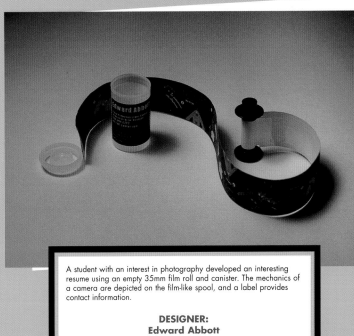

A student with an interest in photography developed an interesting resume using an empty 35mm film roll and canister. The mechanics of a camera are depicted on the film-like spool, and a label provides contact information.

DESIGNER:
Edward Abbott
(USA)

A baseball-style card promotes a new graduate and her design skills as she enters the "major leagues." Four additional cards show samples of her work, and a certificate of authenticity accompanies the campaign.

DESIGNER:
Christine Karst
(USA)

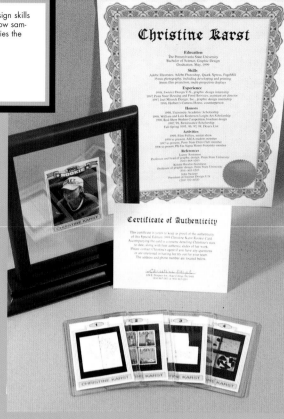

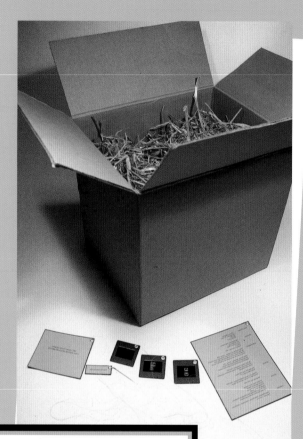

To set himself apart from other new graduates, a young designer placed his resume, work samples and a needle at one end of a length of fishing wire before burying it in a box of hay. The other end of the wire was attached to a note on top of the hay, positioning the designer as the "needle in the haystack" the employer was seeking.

DESIGNER:
Ryan O'Rourke
(USA)

Less is more in this resume for a recent graduate and aspiring designer. Her tiny resume is inserted in a cracked walnut, which is reassembled with glue before being mailed to prospective employers with a nutcracker.

DESIGNER:
Brandy Taylor
(USA)

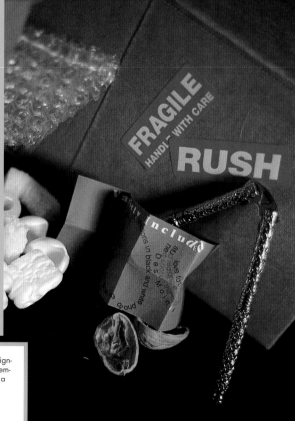

Showing a playful approach to the business of securing employment, this student promotion is a take-off on a board game. Copy inside indicates that "you can't lose with Garland Merfeld on your creative team."

DESIGNER:
Garland Merfeld
(USA)

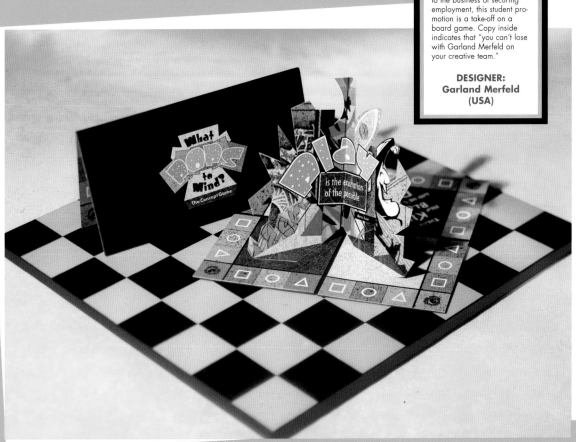

A new graduate announces her arrival to potential employers with a cloth diaper. The designer's sense of humor shows with the gift of a small candy bar inside the diaper and her "brief resume" on the diaper's backside.

DESIGNER:
Stephanie Nace
(USA)

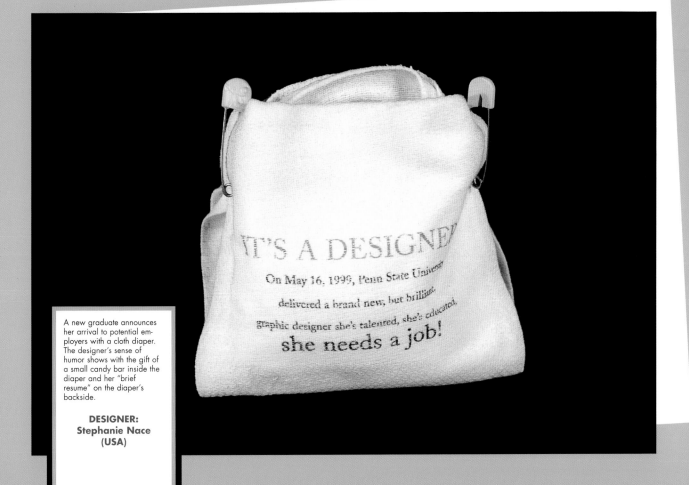

Combining a personal interest in ceramic tile design with the need to announce a sabbatical from her graphic design business, this designer sent a small tile magnet to those on her mailing list.

**DESIGN FIRM:
Our House Design
Group
(USA)**

Its annual holiday party being catered by a local martini bar, this firm sent screen printed cocktail napkins to invitees. The napkins fit perfectly into standard 5"-square envelopes.

**DESIGN FIRM:
Hauptman & Partners
(USA)**

To announce the posting of Thoma Thoma Creative's Web site to clients and prospects, the firm developed a postcard around the headline "Siteseeing?" Other cards in the series were used to display new work and announce a move.

**DESIGN FIRM:
Thoma Thoma Creative
(USA)**

An announcement of Bradbury Design's ten-year anniversary, this calendar is reusable year after year. Three separate banks—one each for month, date and weekday allow flexibility and add interest.

**DESIGN FIRM:
Bradbury Design
(Canada)**

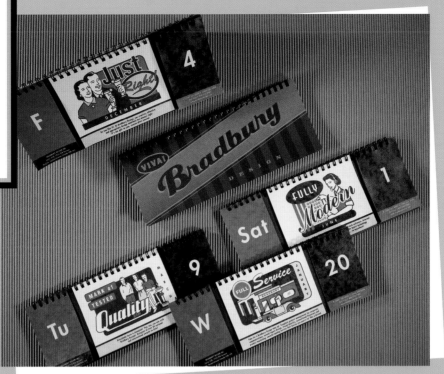

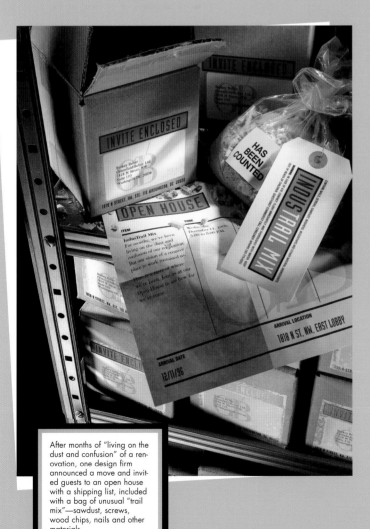

After months of "living on the dust and confusion" of a renovation, one design firm announced a move and invited guests to an open house with a shipping list, included with a bag of unusual "trail mix"—sawdust, screws, wood chips, nails and other materials.

**DESIGN FIRM:
Greenfield/Belser
(USA)**

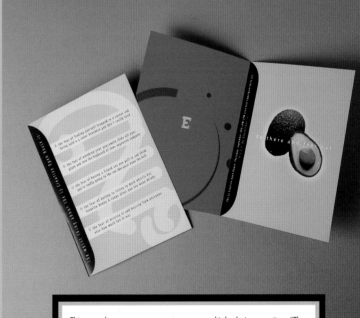

This open house announcement poses a multiple-choice question: "The worst thing about the L3 Creative open house is:" A series of witty possible answers follows. The correct choice, of course, is the last answer: "The fear of missing it and hearing from everyone else how much fun it was."

**DESIGN FIRM:
L3 Creative
(USA)**

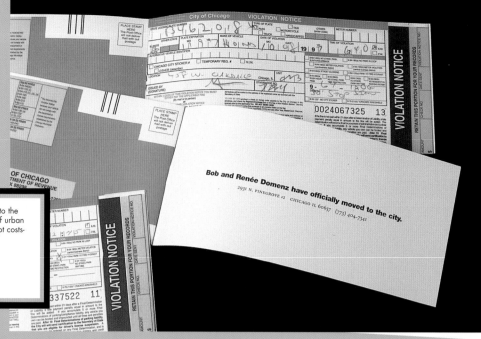

In announcing his family's move from the suburbs to the city, this designer used the quintessential symbol of urban living: a parking ticket. Scanning actual tickets kept costs—and design time to a minimum.

DESIGN FIRM:
VSA Partners
(USA)

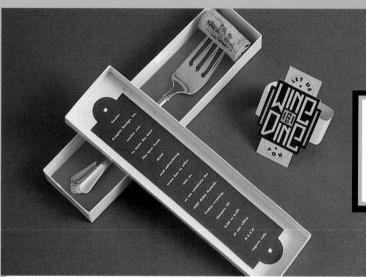

A wine cork is pierced by the tines of a fork and placed in a stock box to underscore the "Let Us Wine and Dine You" theme of the invitation. A printed card with the event's date and time is adhered to the box lid.

DESIGN FIRM:
Sayles Graphic Design
(USA)

This low-budget invitation to a publisher's picnic features a one-color cover, printed on a yellow paper stock. A miniature plastic hot-dog charm adds interest with a minimal investment.

DESIGNER:
Jannelle Schoonover for F&W Publications
(USA)

This designer was "turning 26 and getting excited," so he invited his friends to a party with a unique invitation. A small chain is riveted to the invitation, and recipients' attention was riveted to the chain's expression of the birthday boy's enthusiasm.

DESIGN FIRM:
Sagmeister Inc.
(USA)

A design team developed a unique invitation to a talk about how they "set sail" in the graphic design industry. A "do-it-yourself" invitation promoted the event. The perforated mailer became a three-dimensional sailboat propped on an easel.

DESIGN FIRM:
Sayles Graphic Design
(USA)

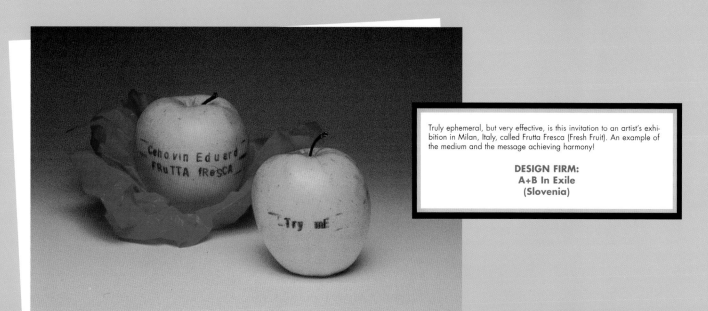

Truly ephemeral, but very effective, is this invitation to an artist's exhibition in Milan, Italy, called Frutta Fresca (Fresh Fruit). An example of the medium and the message achieving harmony!

DESIGN FIRM:
A+B In Exile
(Slovenia)

A variety of found papers gives texture and warmth to Elvis Swift's self-mailing booklet. The Renaissance style of the illustrator is captured on lightweight, translucent pages held together with a round-head fastener. A sticker holds the piece closed, and a die-cut area on the back cover allows the mailing address to show through.

**REPRESENTATIVE:
Joanie Bernstein
(USA)**

A three-part mailing for an advertising agency uses fly fishing as a metaphor for its services. The initial two mailers are sent "blind," the final piece outlines the agency's philosophy and shows some of its work.

**AGENCY:
Henry Russell Bruce
(USA)**

Two amusing mailers by Thomas C. Porter & Associates announced the hiring of a new creative director and a public relations specialist. The mailers resulted in a number of new projects, including one from an existing client who didn't realize the agency had a public relations department!

AGENCY:
Thomas C. Porter & Associates
(USA)

Inviting potential clients to "Have a Mug on Us," a Seattle design firm includes a leather coaster in its self-mailing promotion. Fashioned from cardboard, the mailer is sturdy and credible.

DESIGN FIRM:
Z Group Design
(USA)

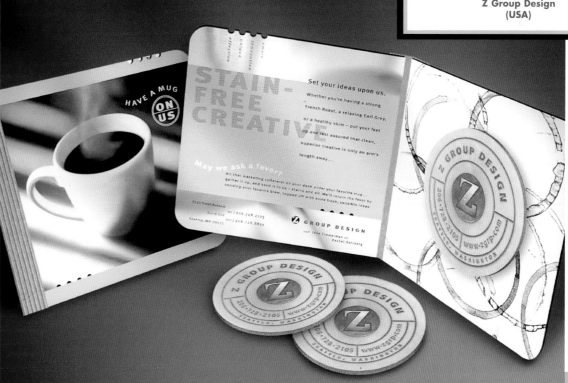

116

Affordable one-color printing is effectively used in a pair of accordion-fold mailers featuring a die-cut window. The "Success" card is sent to potential clients to introduce the firm and set up a meeting. Personal messages are handwritten in white ink on the black panel.

**DESIGN FIRM:
Grace Design
(USA)**

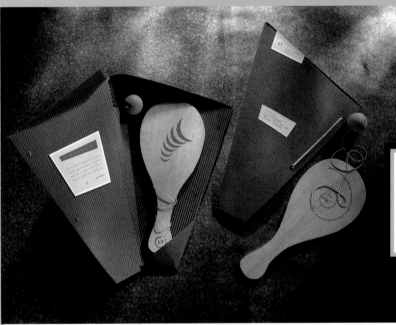

Proclaiming "We'd like to bounce some ideas off of you," this mailer contains a paddle and ball stamped with the firm's logo. The package is fashioned from single-wall corrugated and closed with a wire-and-rubber band combination.

**DESIGN FIRM:
L3 Creative
(USA)**

Done on an extremely limited budget, this postcard mailer gets right to the point. The mailing side included a personal message from the sender.

**DESIGNER:
Kimberly Boyd
Vickrey
(USA)**

A fun mailer promotes design services to a specific market: pharmaceutical companies. Images of a German studio's work are found inside the small plastic television included in the mailing.

DESIGN FIRM:
Pharma Performance
(Germany)

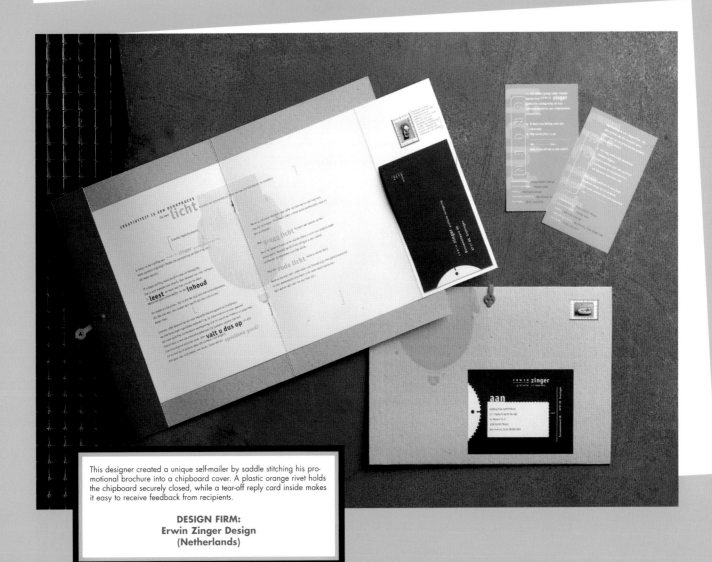

This designer created a unique self-mailer by saddle stitching his promotional brochure into a chipboard cover. A plastic orange rivet holds the chipboard securely closed, while a tear-off reply card inside makes it easy to receive feedback from recipients.

DESIGN FIRM:
Erwin Zinger Design
(Netherlands)

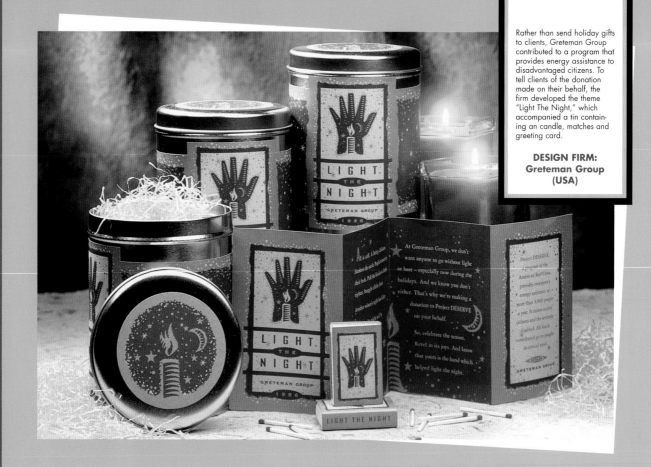

Rather than send holiday gifts to clients, Greteman Group contributed to a program that provides energy assistance to disadvantaged citizens. To tell clients of the donation made on their behalf, the firm developed the theme "Light The Night," which accompanied a tin containing an candle, matches and greeting card.

DESIGN FIRM:
Greteman Group
(USA)

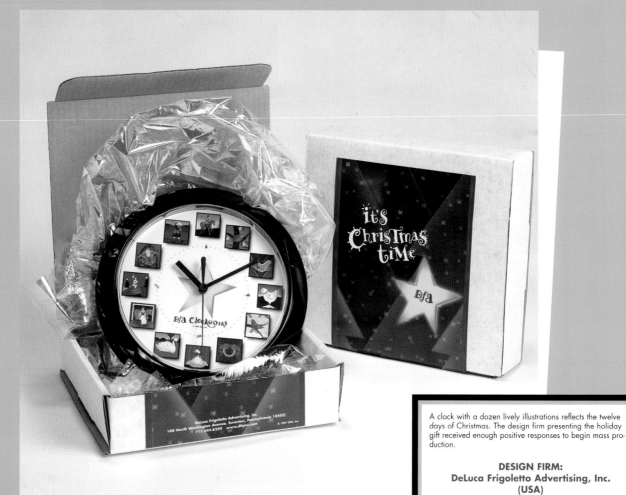

A clock with a dozen lively illustrations reflects the twelve days of Christmas. The design firm presenting the holiday gift received enough positive responses to begin mass production.

DESIGN FIRM:
DeLuca Frigoletto Advertising, Inc.
(USA)

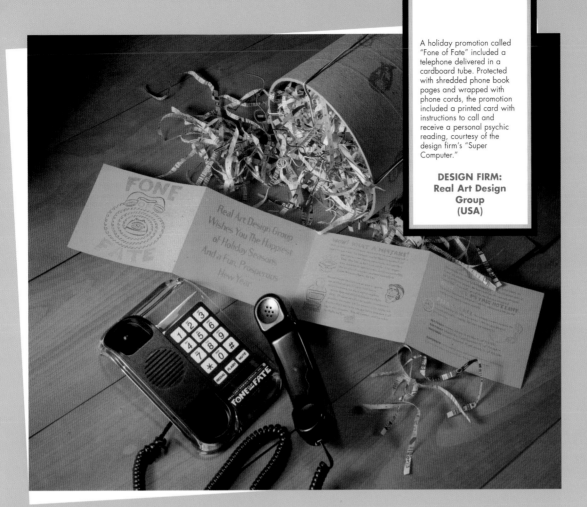

A holiday promotion called "Fone of Fate" included a telephone delivered in a cardboard tube. Protected with shredded phone book pages and wrapped with phone cords, the promotion included a printed card with instructions to call and receive a personal psychic reading, courtesy of the design firm's "Super Computer."

DESIGN FIRM:
Real Art Design
Group
(USA)

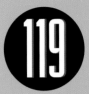

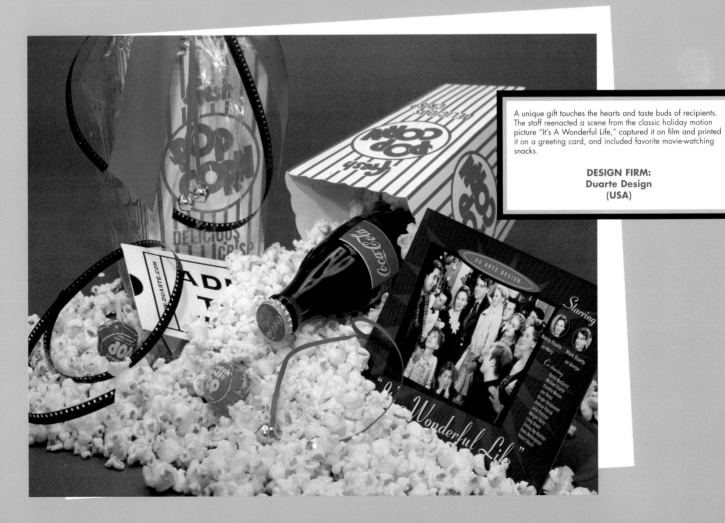

A unique gift touches the hearts and taste buds of recipients. The staff reenacted a scene from the classic holiday motion picture "It's A Wonderful Life," captured it on film and printed it on a greeting card, and included favorite movie-watching snacks.

DESIGN FIRM:
Duarte Design
(USA)

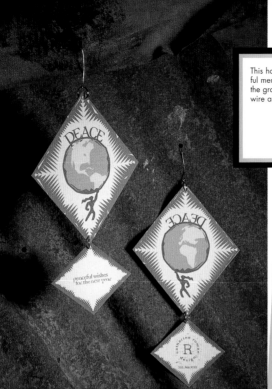

This hand-assembled holiday ornament is a personalized gift, thoughtful memento and recurring promotion all in one. The designer printed the graphic, affixed it to chipboard and connected the pieces with wire and a hook.

DESIGNER:
Catherine Roman
(USA)

Continuing a tradition of holiday contributions in lieu of client gifts, Greteman Group made a sizable donation to an area food bank. Clients received a handmade mug, soup mix and recipe with the message that through the gift made on their behalf, they were helping "Feed The Need."

DESIGN FIRM:
Greteman Group
(USA)

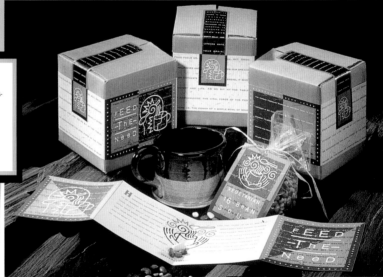

Spinning off a previous holiday promotion of gift tags, Vrontikis Design added gift wrap to their 1997 mailing.

DESIGN FIRM:
Vrontikis Design Office
(USA)

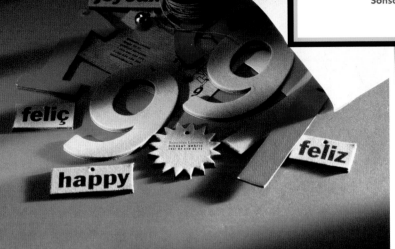

Recipients of this holiday greeting have a visible reminder of the new year when they put together a do-it-yourself mobile. Numbers, greetings and the designer's phone number are printed on heavy chipboard and accompanied by a length of twine and instructions for assembly.

DESIGN FIRM:
Sonsoles Llorens Studio
(Spain)

Special friends and clients receive many gifts, but few with the dual holiday message of giving and thanks. This wine bottle's label uses the two words with a typographic twist: "thanks" reads one way, and "giving" reads the other.

DESIGNER FIRM:
Wallace/Church
(USA)

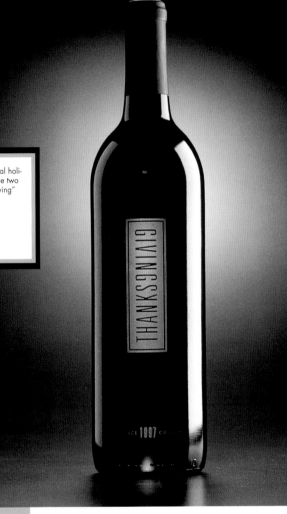

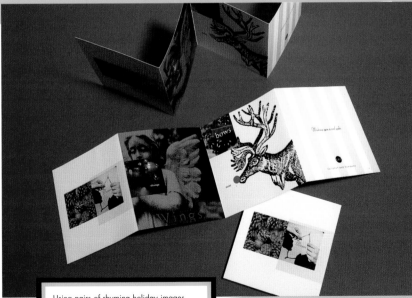

Using pairs of rhyming holiday images (nose/bows, etc.), this agency sought a minimalist approach to the business of saying, "Happy holiday." A variety of techniques—including a duotone, vintage photo, line art and four-color photo—result in a rich and readable presentation.

DESIGNER FIRM:
Callahan and Company
(USA)

A gift set of holiday pencils is a reminder to "make your mark" in the new year. Each pencil is foil stamped with powerful words like passion, humility and respect. The gift is presented in a red velvet pouch with a personal note card attached.

DESIGN FIRM:
Melissa Passehl
Design
(USA)

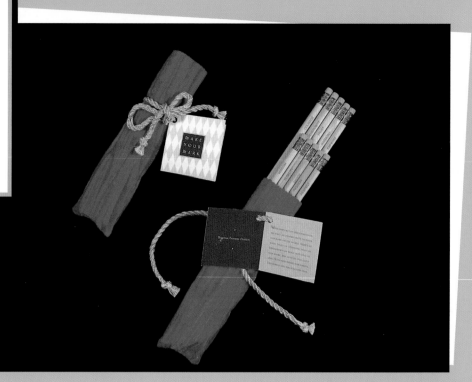

An unusual Christmas greeting conveys the double meaning of iron: the lucky symbolism of the horseshoe and the necessity of the mineral for the human body's good health. The holiday greeting was written in a medical instructional format.

DESIGN FIRM:
Tangram Strategic Design
(Italy)

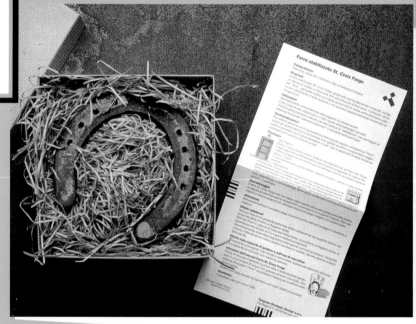

During the year, extra room on press sheets are filled with "to & from" tags for holiday gifts. Each year the tags are packaged and sent to clients, prospects, vendors and friends for their use.

DESIGN FIRM:
Vrontikis Design Office
(USA)

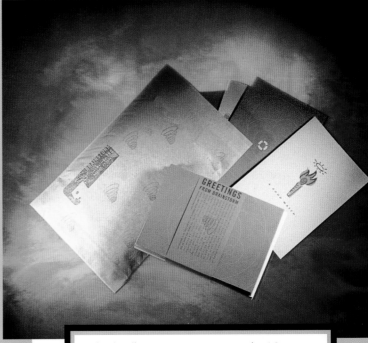

An ordinary T-shirt is transformed into a holiday gift by incorporating Thoma Thoma's strongly branded T monogram. A "Christmas Tee" is presented in a box decorated with tree ornaments.

DESIGN FIRM:
Thoma Thoma
Creative
(USA)

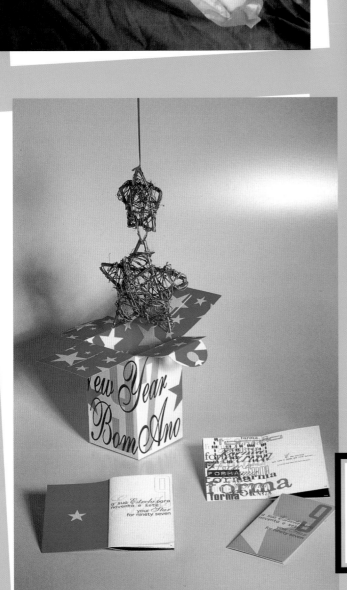

A gift and a self-promotion in one inexpensive package! Greeting cards created for a client are reproduced (with the client's permission), wrapped with a quick-printed band and shipped in an envelope decorated with custom rubber stamps.

DESIGN FIRM:
Brainstorm, Inc.
(USA)

Entitled "Your Star for Ninety-Seven," this 1997 New Year's greeting includes a brochure and custom star ornament in a beautiful square box. The star theme carries through the copy in the brochure.

DESIGN FIRM:
Mario Aurélio & Associados
(Portugal)

A memorable holiday gift is created from a stock tin lined with corrugated, filled with chocolates, and decorated with a label printed using 1950s-style graphics. A tiny brochure inside the tin features greetings from the creative staff, by way of their childhood photos.

DESIGN FIRM:
Star Tribune Creative
(USA)

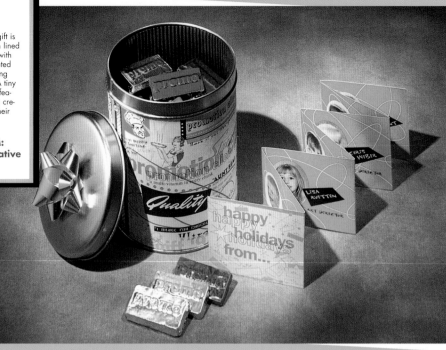

Leftover paper and two screen-printed colors of ink kept costs down but still made recipients of this holiday card smile with wishes like, "Maybe dogs need presents too."

DESIGN FIRM:
Planet Design Co.
(USA)

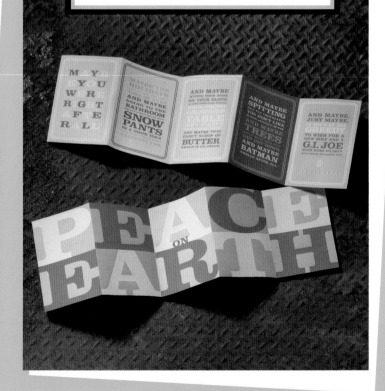

A two-color poster is a humorous seasonal greeting. Tongue-in-cheek illustrations of family members help the design firm wish recipients a "relatively painless" holiday.

DESIGN FIRM:
Brainstorm, Inc.
(USA)

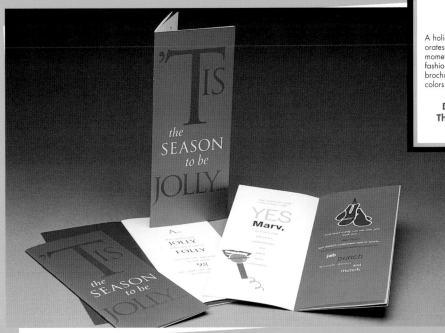

A holiday greeting commemorates the year's "jolly" moments in "folly" humorous fashion. The booklet-style brochure is printed in two colors.

DESIGN FIRM:
The Bond Group
(USA)

Cleverly playing off the name of the advertising principal (Randy Gunter), this holiday greeting contains a toy ray gun. Recipients reported "gun fights" breaking out in offices for weeks afterward.

AGENCY:
Gunter Advertising
(USA)

A young firm didn't have the resources to formally entertain clients during the holidays, so they sent a gift of gourmet pasta and sauces and invited recipients to cook for themselves. The pasta sauce was so popular, it was also presented alone to prospective clients with the line, "Sometimes to get new business, you have to pour it on thick."

DESIGN FIRM:
DeLuca Frigoletto Advertising, Inc.
(USA)

Freelance designer Catherine Roman uses postcards to thank current and potential clients. The postcards are printed with illustration samples and mailed in glassine envelopes or given in person.

DESIGNER:
Catherine Roman
(USA)

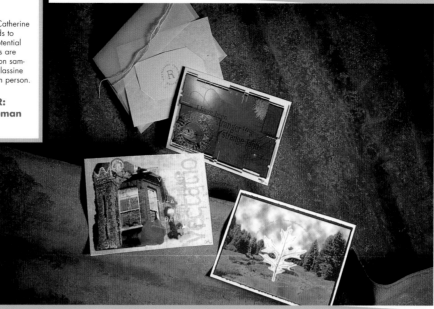

Oversized cards are sent in glassine envelopes, allowing a photographer's work to show through even before the mail is opened. Changing the location of headlines, photos and copy in the layouts creates variety but maintains consistency and recognition by the recipient.

PHOTOGRAPHER:
David Morris Photography
(USA)

A simple black wrap houses twelve individual image cards in this promotion for a Midwestern photographer. The layout of the cards is consistent and simple, directing attention to the photographer's work.

PHOTOGRAPHER:
Dreasher Photography
(USA)

Rich images of Paris are combined in this unique self-promotion for a Houston photographer. Thirteen visuals of the famous city are printed on the 24" x 36" sheet, which can be separated along the perforated lines for a set of beautiful postcards. The back of the poster is printed with a faint image of the Eiffel Tower, and captions are printed in both English and French.

PHOTOGRAPHER:
Terry Vine
(USA)

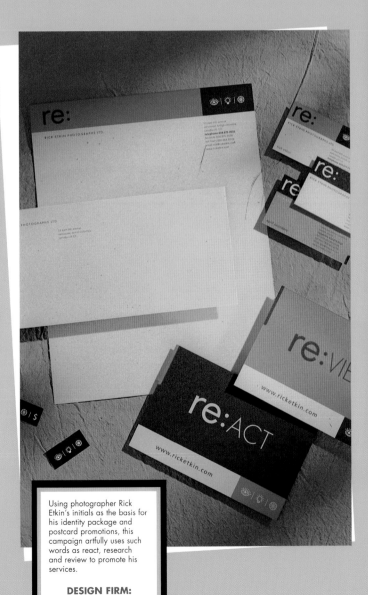

Using photographer Rick Etkin's initials as the basis for his identity package and postcard promotions, this campaign artfully uses such words as react, research and review to promote his services.

DESIGN FIRM:
Karacters Design
Group
(Canada)

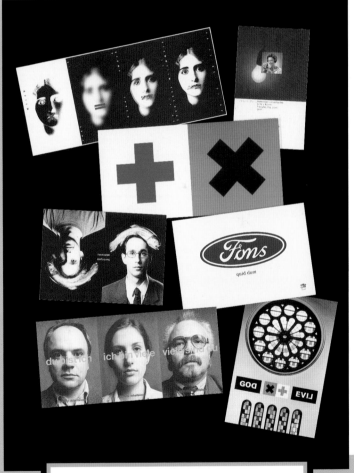

This series of postcards for a German designer also conveys political messages. A spoof on the Ford logo, for example, has the subhead *quid dum*, which means "so what."

DESIGN FIRM:
Fons M. Hickmann
(Germany)

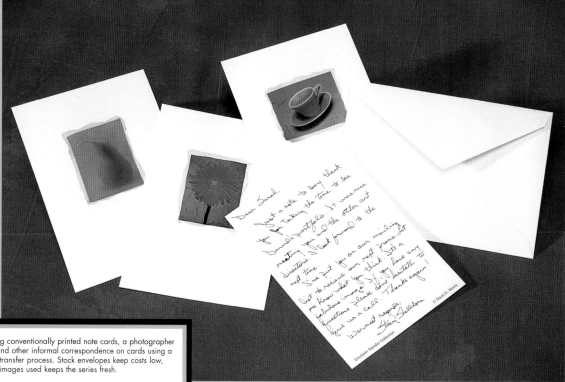

Rather than sending conventionally printed note cards, a photographer sends thank-yous and other informal correspondence on cards using a Polaroid emulsion transfer process. Stock envelopes keep costs low, and the variety of images used keeps the series fresh.

PHOTOGRAPHER:
David Morris Photography
(USA)

A series of note-card images transcends the ordinary with the use of a common die cut on the covers of each. While the view through the die cut shows an abstract image, when the card is opened, the full sample of Penina Photography's work is revealed.

DESIGN FIRM:
Fuel
(USA)

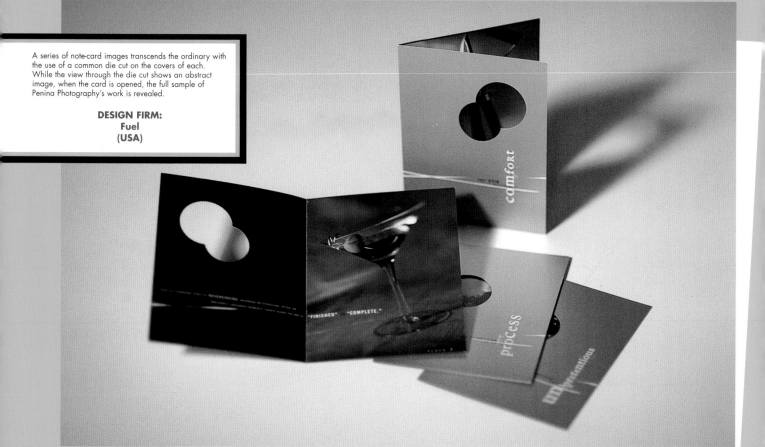

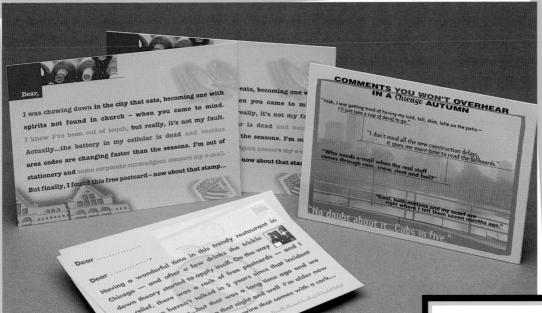

Bond Design uses a series of humorous postcards to get its name out to a wide audience. The fill-in-the-blank approach to the copy on the cards allows the reader to personalize the message as needed.

DESIGN FIRM:
The Bond Group
(USA)

Short, clever copy makes this illustrator's postcard series a standout. An illustration of an elephant, for example, reads "Hardworking. Gentle disposition. Not a bad memory, either." The inference being that the attributes of the elephant are shared by the illustrator.

ILLUSTRATOR:
Jerry Lofaro Studio
(USA)

A wooden stick and rubber band bind together a series of cards printed with lively images and type. Each photo displays a new project by the design firm.

DESIGN FIRM:
Metzler & Associates
(France)

Following the overwhelming popularity of a series of opera posters for the Connecticut Grand Opera and Orchestra, the design firm removed the dates and times from the 17" x 31" images, added a small calendar at the bottom of each page, and created a collectors' item for poster and opera fans alike.

DESIGN FIRM:
Tom Fowler, Inc.
(USA)

PRESENTED HERE IN CALENDAR FORM IS AN AWARD WINNING COLLECTION OF POSTERS CREATED AND PRODUCED FOR THE CONNECTICUT GRAND OPERA AND ORCHESTRA • THE POSTERS HAVE BEEN REPRODUCED EXACTLY AS THEY FIRST APPEARED EXCEPT WITH THE DELETION OF TEXT PERTAINING TO THE DATE, TIME AND PLACE • SEVERAL OF THE ORIGINAL POSTERS ARE NOW IN PROMINENT PRIVATE COLLECTIONS THROUGHOUT THE WORLD AS WELL AS IN THE PERMANENT GRAPHICS COLLECTION OF THE "MUSEUM FÜR KUNST UND GEWERBE HAMBURG" (MUSEUM OF DECORATIVE ARTS) IN HAMBURG, GERMANY • IN ADDITION TO BEING PUBLISHED IN NUMEROUS NATIONAL AND INTERNATIONAL ART AND DESIGN PUBLICATIONS, TWO OF THE POSTERS ARE NOW PART OF A WORLD TOUR EXHIBITION SPONSORED BY THE GOVERNMENTS OF THE U.S. AND POLAND • WE HOPE YOU ENJOY DISPLAYING THIS LIMITED EDITION PRINTING OF THESE POSTERS AS MUCH AS WE ENJOYED CREATING THEM

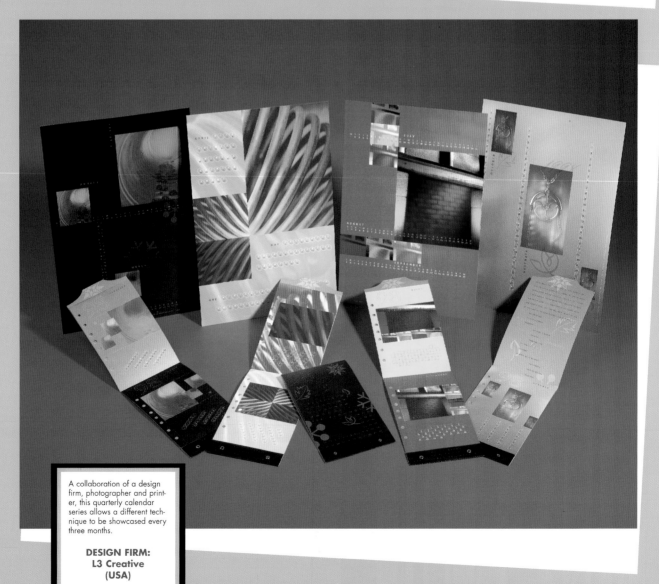

A collaboration of a design firm, photographer and printer, this quarterly calendar series allows a different technique to be showcased every three months.

DESIGN FIRM:
L3 Creative
(USA)

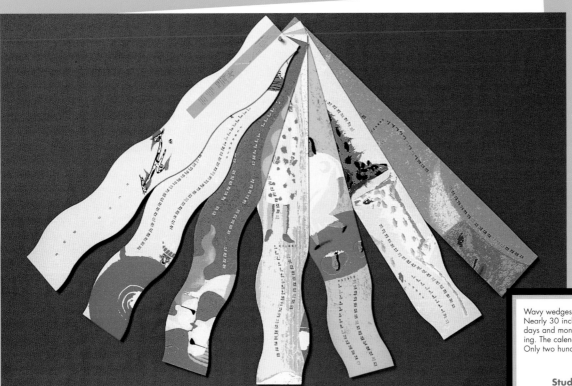

Wavy wedges of thin wood form an unusual wall calendar.
Nearly 30 inches in length, each piece is printed with the
days and months and attached to a bracket for wall hang-
ing. The calendar is signed and numbered by the artist:
Only two hundred were produced.

DESIGN FIRM:
Studio Grafico Fausta Orecchio
(Italy)

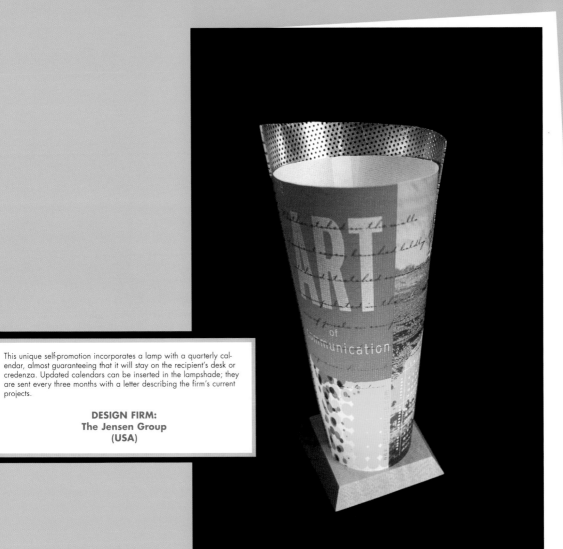

This unique self-promotion incorporates a lamp with a quarterly cal-
endar, almost guaranteeing that it will stay on the recipient's desk or
credenza. Updated calendars can be inserted in the lampshade; they
are sent every three months with a letter describing the firm's current
projects.

DESIGN FIRM:
The Jensen Group
(USA)

A wire-o bound calendar is a year-long promotion. Illustrated in a watercolor style, days and dates are printed on shorter pages. The brief, visual message for each month highlights one of the thirty articles of the "Declaration of Rights." The designer included his photo and biography in the back, as well as contact information.

DESIGN FIRM:
Alberto Ruggieri e
Interno Otto
(Italy)

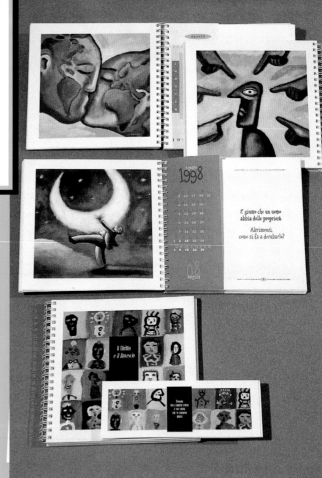

Baker Design Associates announced its thirteen-year anniversary with a calendar playing off a theme of "luck and good fortune." The 4½" x 3" wire-o booklet alternates calendar pages with appropriate quotes and sayings. Sample messages are, "The harder you work, the luckier you get," and "Sometimes it's hard to tell a broken dream from a lucky break."

DESIGN FIRM:
Baker Design Associates
(USA)

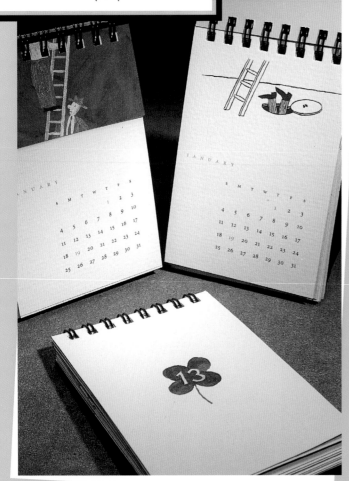

Using "clink" as a headline (and "bottoms up!" as the subhead), this promotion is a combination calendar and cocktail recipe collection. Printed on an indigo printer, the small-run job was a cost-effective holiday greeting.

DESIGN FIRM:
Queen Bee Creative
(USA)

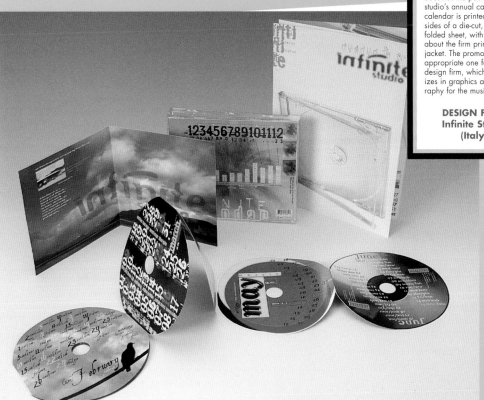

A plastic compact disc case becomes the package for this studio's annual calendar. The calendar is printed on both sides of a die-cut, accordion-folded sheet, with details about the firm printed on the jacket. The promotion is an appropriate one for the design firm, which specializes in graphics and photography for the music industry.

DESIGN FIRM:
Infinite Studio
(Italy)

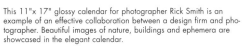

This 11"x 17" glossy calendar for photographer Rick Smith is an example of an effective collaboration between a design firm and photographer. Beautiful images of nature, buildings and ephemera are showcased in the elegant calendar.

DESIGN FIRM:
Shapiro & Walker Design
(USA)

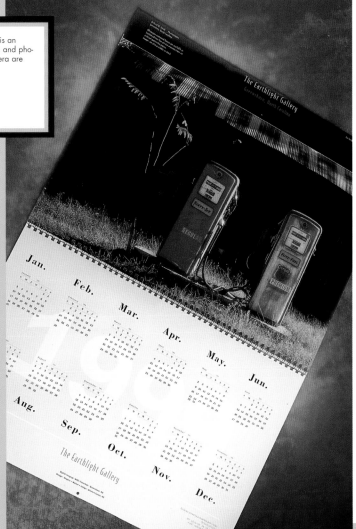

BIOGRAPHIES

John Hornall and Jack Anderson
Partners, Hornall Anderson Design Works

John Hornall and Jack Anderson founded Hornall Anderson Design Works in 1982. John, who is also president, is responsible for overall management and design review. His twenty-five-year career includes assignments for the Northwest's top industrial and service companies. He also teaches at the University of Washington and Seattle's School of Visual Concepts. Jack puts his efforts into creative direction and project management. The firm's diverse list of clients includes Microsoft, Starbucks Coffee Company, Pepsi, Kraft Foods and Adobe.

Scott Mires
President/ Art Director, Mires Design Inc.

A 1982 graduate of San Diego State University, Scott Mires has led Mires Design since 1986. Market-leading clients such as Intel, Nike, Pepsi and Harcourt Brace consistently look to Scott and his team for their creative expertise and diligent follow-through to help them with brand-development. Scott has been recognized by industry publications and organizations including *Graphis*, *Print* magazine, AIGA, Type Directors Club and *HOW* magazine. He has spoken at AIGA national and regional conferences, written commentary for *Graphis* and judged Communication Arts annual design competitions.

John H. Sayles
Principal/Art Director, Sayles Graphic Design

John Sayles worked for two Des Moines advertising agencies before starting Sayles Graphic Design in 1985 with his former client, Sheree Clark. The firm specializes in corporate identity programs, direct mail, package and product development. John's work is included in the permanent collection of the Smithsonian Institution's Cooper-Hewitt National Design Museum and he has received over 500 awards for design excellence, including four national ADDY awards. The firm's work has been featured in international publications including *Advertising Age*, *Applied Arts*, *Communication Arts*, *HOW*, *Graphis*, *Print*, and *Step-By-Step Graphics* magazines as well as design annuals and reference books.

Karen Johnson
Principal, Johnson Design Group

Since 1984, Karen Johnson has led Johnson Design Group's team, providing unique communication design services for the firm's regional, national and international clients. She studied at the Kendall School of Art & Design and has won a variety of awards since founding her firm, whose services include planning and research, brand identity, multimedia, print collateral and signage. Karen's contributions to the community include pro bono work for a number of youth and benefit organizations.

Scott Hull
Principal,
Scott Hull Associates

"I am what I am," says artist representative Scott Hull of his role of matching clients with just the right artist and overseeing the creative process of each project. Scott's inherent insight into the visual communications business comes from his own talent, education and early career experience as a designer. Scott Hull Associates is a creative alliance of individuals who exhibit outstanding artistic talent, while placing an emphasis on superior customer service skills and an on-time, on-budget approach. Scott and his team go the extra mile to assist both illustrators and clients in realizing the hidden potential for their creations, including optimizing publicity and possible licensing opportunities.

Richard Hollant
Winston•Ford Design

When a Boston University honors student in philosophy does a thesis on "the philosophy and psychology of aesthetics towards an empirical understanding of creativity," a career in design can't be far behind. Richard Hollant founded Winston•Ford Design with wife Bonnie in 1988. Today both Hollants put their creative and technical expertise to work for clients such as Aetna, Harcourt Brace College Publishers and Harley-Davidson. Hollant's work is included in the permanent collection of the Library of Congress and has been recognized by the Connecticut Art Directors Club and the New England Direct Marketing Association. In 1999, Richard and Bonnie Hollant transformed their firm into a new design studio called Listen.

Supon Phornirunlit
Creative/Art Director,
Supon Design Group

Since founding the company at the age of 24, Supon Phornirunlit and his design team have earned over 700 awards, including recognition from every major national design competition. The studio specializes in logo and identity design, and has created graphics for numerous high-profile organizations. Supon Design Group has an international roster of clients, including IBM, Coca-Cola, the Discovery Channel and the U.S. Postal Service. The firm's work has appeared in *Graphis*, *Communication Arts*, *Print*, *Step-By-Step Graphics* and *HOW*. Supon regularly speaks and judges at various organizations and schools.

CONTRIBUTORS' INDEX

All the following pieces are used by permission.

A+B (In Exile)
Eduard Cehovin
Parmova 20
1000 Ljubljana SLOVENIA
Phone 386 61 1343 142
Fax 386 61 1343 142
Pages 94, 113

Edward Abbott
22 Alcott Drive
Wilmington, Delaware 19808 USA
Phone (302) 998–3222
Page 107

Alan Brooks Design
Alan Brooks
20 Wassau Street
Suite 229
Princeton, New Jersey 08542 USA
Phone (609) 924–3838
Fax (609) 924–0088
Page 79

Alberto Ruggieri e Interno Otto
Alberto Ruggieri
Via Miani 6
00154 Rome ITALY
Phone 39 6 5781637
Fax 39 6 5781637
Page 132

Ana Couto Design
Ana Couto
Rua Joana Angelica
173–4 Andar
Rio de Janeiro RJ 22420–030 BRAZIL
Phone 55 21 287 7069
Pages 36–37

The Attik
Rachel Sykes
Stonewood 87 Fitzwilliam Street
Huddersfield HD1 5LG

UNITED KINGDOM
Phone 01 484 537 494
Fax 01 484 434 958
Page 104

Baker Design Associates
1411 Seventh Street
Santa Monica, California 90401 USA
Phone (310) 393–3993
Fax (310) 394–4705
Page 132 © Baker Design Associates

Bakker Design
Doug Bakker
4507 98th Street
Urbandale, Iowa 50322 USA
Phone (515) 270–9527
Fax (515) 270–0036
Page 75

Balance Design
Pat Propes
13003 Pine Hill Court
Prospect, Kentucky 40059 USA
Phone (502) 228–9044
Fax (502) 228–7030
Page 101

Belyea Design Alliance
Patricia Belyea
1809 Seventh Avenue
Suite 1700
Seattle, Washington 98101 USA
Phone (206) 682–4895
Fax (206) 623–8912
Page 80

Big Fish Design
Paul Ocepek
9 Claremont Avenue
Arlington, Massachusetts 02476 USA
Phone (781) 646–8623
Fax (781) 646–8598
Page 90

Dave Blank
343 Fourth Avenue #201
San Diego, California 92101 USA
Phone (619) 233–9633
Fax (619) 233–9637
Page 107

The Bond Group
Cindy Bond
833 West Chicago Avenue
Chicago, Illinois 60622 USA
Phone (312) 563–1185
Fax (312) 563–1202
Pages 100, 125, 129 © The Bond Group, Inc.

Bradbury Design
Catharine Bradbury
1933 Eighth Avenue
Suite 330
Regina, Saskatchewan S4R 1E9
CANADA
Phone (306) 525–4043
Fax (306) 525–4068
Pages 75, 93, 111

David Bradley
13 Annabelle Street
Newark, Delaware 19711 USA
Phone (302) 266–6466
Page 105

Brainstorm, Inc.
Chuck Johnson
3347 Halifax Street
Dallas, Texas 75247 USA
Phone (214) 951–7791
Fax (214) 951–9060
Pages 88, 123, 124

Brand A Studio
Guthrie Dolin
245 South Van Ness #302
San Francisco, California 94103 USA
Phone (415) 552–4900
Fax (415) 552–4901

Fax (502) 745–5932
Pages 105, 116

L3 Creative
Lisa Ledgerwood
2720 East Camelback
Suite 295
Phoenix, Arizona 85016 USA
Phone (602) 954–6992
Fax (602) 954–6884
Pages 84, 97, 111, 116, 130

Labbé Design
Jeff Labbé
2046 NW Flanders Street #34
Portland, Oregon 97209 USA
Phone (503) 219–9768
Fax (503) 226–7578
Pages 95, 98

Likovni Studio
Tomislav Mrcic
Dekanici 42, Kerestinec
Sveta Nedjelja, HR–10431, CROATIA
Phone (385) 1 870 593
Fax (385) 40 310825
Pages 86, 98

Listen (formerly Winston•Ford)
Richard Hollant
444 Kendall Street
New Haven, Connecticut 06512 USA
Phone (203) 467–0003
Fax (860) 560–0274
Pages 68–71

Lloyds Graphic Design
Alexander Lloyd
Top Floor, Lloyd House
35 Dillion Street
Blenheim NEW ZEALAND
Phone 64 3 578 6955
Fax 64 3 578 6955
Pages 90, 93, 105

Mario Aurélio & Associados (MA&A)
Mario Aurélio
R. Cidade Do Recife 232, 3E
4200 Porto PORTUGAL
Phone 351 2 610 1119
Fax 351 2 610 1198
Page 123

Matite Giovanotte
Maria Flamigni
Via Degli Orgogliosi 15
47100 Forli ITALY
Phone 39 543 33349
Fax 39 543 33273
Page 98

McCullough Creative Group, Inc.
Roger Schoubroul
2099 Southpark Court
Dubuque, Iowa 52003–7985 USA
Phone (319) 556–2392
Fax (319) 556–2393
Pages 60–61

Meirding Design
Pam Meierding
311 Fourth Avenue
Suite 614
San Diego, California 92101 USA
Page 83

Melissa Passehl Design
Melissa Passehl
1275 Lincoln Avenue #7
San Jose, California 95125 USA
Phone (408) 294–4422
Fax (408) 294–4104
Page 122

Garland Merfeld
343 Fourth Avenue #201
San Diego, California 92101 USA
Phone (619) 233–9633
Fax (619) 233–9637
Page 109

Metzler & Associates
Marc-Antoine Herrmann
5, Rue de Charonne
75011 Paris FRANCE
Phone 33 1 53 36 13 36
Fax 33 1 53 36 00 26
Pages 97, 129

Mires Design Inc.
Dara Williams
2345 Kettner Boulevard
San Diego, California 92101–1213
USA
Phone (619) 234–6631
Fax (619) 234–1807
Pages 44–47, 101 © Mires Design, Inc.

Morse & Jacobi Advertising Communications, Inc.
Sharee Morse
105 Washington
Michigan City, Indiana 46360 USA
Phone (219) 879–1223
Fax (219) 879–4276
Page 85

Stephanie Nace
210 Patterson Building
University Park, Pennsylvania 16802
USA
Phone (814) 865–1203
Fax (814) 865–1158
Page 109

Nine-Grain Design
Liz Craig
5904 Wooddale Avenue
Edina, Minnesota 55424 USA
Phone (612) 926–7388
Fax (612) 927–5160
Page 91 © 1998 Nine-Grain Design

Nodal Communications
Jeremy Dedic
421 19th Street #1406

INDEX